ANSEL ADAMS

The National Park Service Photographs

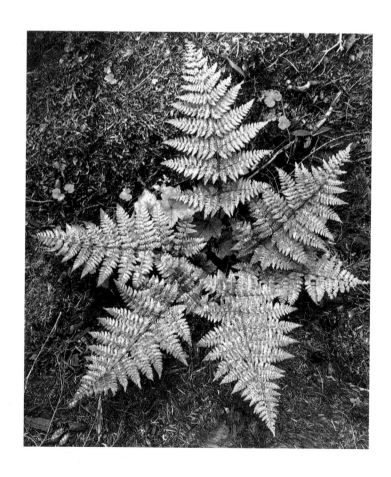

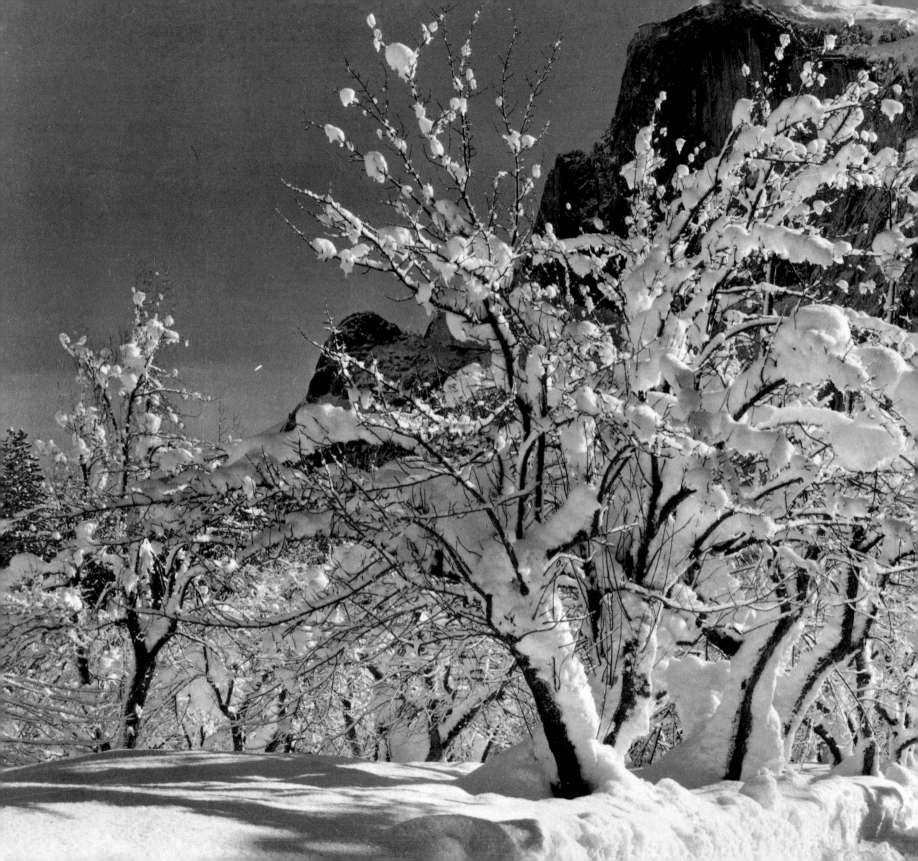

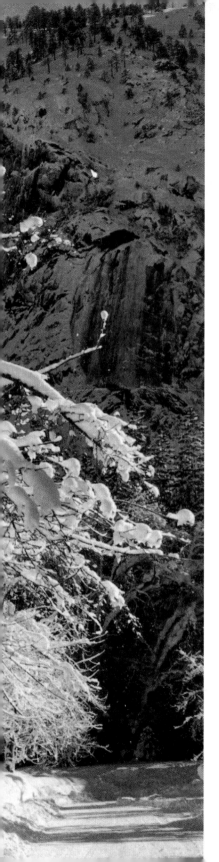

ANSEL ADAMS

THE NATIONAL PARK SERVICE PHOTOGRAPHS

Introduction by Alice Gray

ARTABRAS
A Division of Abbeville Publishing Group
New York London

FRONT COVER: "In Glacier National Park"
BACK COVER: "An Unnamed Peak," Kings River Canyon
HALF TITLE: Plate 1. "In Glacier National Park"
FRONTISPIECE: Plate 2. "Half Dome, Apple Orchard, Yosemite National Park," c. 1930
PAGE 6: Plate 3. "In Glacier National Park"

EDITOR: Jacqueline Decter
DESIGNER: Sandy Burne
PRODUCTION EDITOR: Abigail Asher
PICTURE EDITOR: Laura Straus
PRODUCTION MANAGER: Lou Bilka

First edition without CD ISBN 0-89660-056-4
8 10 12 14 15 13 11 9 7
First edition with CD ISBN 0-7892-0822-9
3 5 7 9 10 8 6 4 2

Grateful acknowledgment is made to the National Archives for the use of the photographic prints reproduced herein. This book is independent of and not authorized by the Ansel Adams Publishing Rights Trust.

Library of Congress Cataloging-in-Publication Data
Adams, Ansel, 1902–
Ansel Adams : the National Park Service photographs / introduction by Alice Gray.
p. cm.
Originally published: New York : Abbeville Press, 1994.
Includes bibliographical references (p.) and index.
ISBN 0-89660-056-4—ISBN: 0-7892-0822-9 (CD)
1. National parks and reserves—West (U.S.)—Pictorial works.
2. Landscape photography—West (U.S.) 2. West (U.S.)—Pictorial works.
I. United States. National Park Service. II. Title.
III. Title: National Park Service photographs.
E160.A298 1995
779'.3678'092—dc20 94-42782

CONTENTS

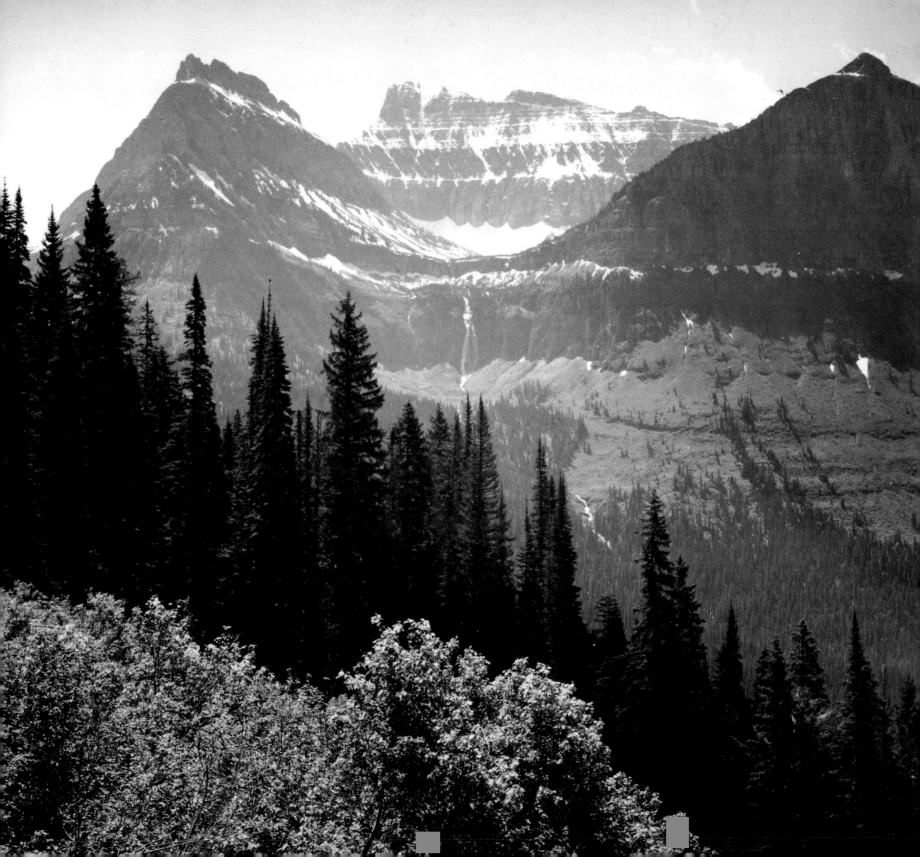

INTRODUCTION

I am the lover of uncontained and immortal beauty. In the wilderness,
I find something more dear and connate than in streets and villages.
In the tranquil landscape, and especially in the distant line of the hori-
zon, man beholds something as beautiful as his own nature.

—RALPH WALDO EMERSON, "Nature"

As artist and activist, Ansel Adams (1902–1984) exerted perhaps the greatest single influence on the concept of an ideal American wilderness. Many of the dramatic, evocative photographs of the western American landscape that Adams produced during his lengthy career are now national icons; his poetic vision of nature frames contemporary debates about the intersection of art and environmentalism. Adams would undoubtedly be pleased that his work continues to inspire artists and conservationists alike, although he claimed he had never consciously made an environmentalist photograph.

Coming of age in the 1930s, Adams was a man of his time and an adherent of the modernist dictum that a work of art should express, above all, the artist's feelings about his subject. To that end, he distinguished between assignments "from within"—images he felt compelled to create—and assignments "from without"—the commercial jobs he accepted in order to make a better living. Adams welcomed any opportunity to hone his craft, and so felt that his commercial projects aided in the development of his creative work, although he clearly preferred the latter. He was among the first and firmest believers in photography as a fine art and not merely as a documentary tool.

In 1941 Adams was offered an assignment "from without" that directly engaged his inner sensibility, one that not only required technical virtuosity but also called upon his self-expression as artist, conservationist, and citizen: he was asked to photograph the national parks, monuments, Indian lands, and reclamation projects administered by the Department of the Interior. The results, reproduced here, represent a pivotal moment in the artist's life and work; they illustrate the culmination of his early innovations and the later direction of his celebrated career.

The invitation to become photo-muralist for the Interior Department was issued by Secretary of the Interior Harold Ickes, who became aware of Adams's work during the 1930s. By 1941 a number of painters had already been commissioned to paint murals on the walls of the new Interior Department building; no photographers were originally included in the Mural Project (as the undertaking was called) because few people then judged photography to be on a par with painting. Ickes, however, had seen a mural-screen depicting a close-up of leaves and ferns that Adams had exhibited in 1936 and had been so impressed with it that he had purchased it for his office the following year. The secretary had also met Adams in 1936 when the photographer came to Washington to lobby Congress for the creation of a national park in Kings River Canyon, California. Adams had been photographing this region of the Sierra Nevada since the 1920s, and his portfolio of majestic images of this towering, snow-capped mountain range with its tree-lined valleys and clear streams (plates 4–18), dating from the mid-1920s to mid-1930s, swayed a number of public officials. Kings River Canyon was made a national park in 1940, and when Adams signed on as photo-muralist for the Interior Department, he agreed to donate the prints he had shown to the government in 1936 as part of his assignment.

The earliest correspondence between Adams and the Interior Department suggests that he was to contribute only a few photographs to the Mural Project. Adams, however, felt that the national parks warranted thorough documentation, and he eventually convinced Ickes

to expand his job. Finally, in October 1941, Adams embarked on a photographic journey that would last until the following summer and would take him to California, Arizona, New Mexico, Utah, Colorado, Wyoming, Montana, and Washington; he was paid the highest rate the government then gave to "outside consultants": $22.22 per day plus expenses. It was agreed that Adams would give his prints to the Interior Department but would retain control of the negatives so as to supervise their final printing, and that he would be free to pursue other personal or commercial projects while en route through the West.

The Mural Project was the ideal assignment for Adams in 1941 because it would allow him to express many of his strongest, most defining convictions. The inextricable link between Adams's art and his favorite subject—the American West—had first been forged in Yosemite National Park in 1916. Fourteen-year-old Ansel arrived in Yosemite on a family vacation away from his San Francisco home armed with his first camera, a Kodak Box Brownie. Amid the dark forests and sweeping mountain skyline, Adams fell in love with the wilderness and with his ability to capture it on film. He would return to Yosemite every year thereafter, eagerly photographing the new world he was discovering through his own eyes and the camera lens.

Adams's formal education ended when he graduated from the eighth grade. An exceptionally bright and active child, he did not thrive in the classroom but undertook his own pursuits with remarkable zeal. In 1915 his father gave him an unlimited pass to the Panama-Pacific Exposition in San Francisco; this was Adams's classroom, and he was particularly taken with the art galleries and photographic displays. At the time, however, Adams's primary interest was music, and he continued to train as a concert pianist until 1930, when a fortuitous encounter with the renowned photographer Paul Strand convinced him that photography, rather than music, was his true calling.

A prodigiously talented pianist, Adams found similarities between music and photography very early on, and for some time he attempted to pursue both professions. Throughout his life he likened the tonal values in a photograph to musical notes. "The negative is comparable to the composer's score and the print to its performance," he would say. His photographic career began in earnest in 1919, when he spent the first of many summers working in Yosemite, initially as custodian of the Sierra Club Lodge and then as a guide for the Sierra Club's month-long treks through the parkland. Adams documented these outings and

began developing his own aesthetic while photographing Yosemite's glorious vistas. Ansel found love in Yosemite, too, for it was here that he met and eventually married Virginia Best, whose father ran Best's Photographic Studio in the park. In 1937 Ansel, Virginia, and their two children moved to Yosemite, having inherited the studio from Virginia's late father. Although Adams traveled a great deal, and would later settle in Carmel, California, Yosemite National Park remained his spiritual home. It was in Yosemite, marveling at the massive granite face of Half Dome under a moonlit sky or the arabesques of snow-covered tree limbs in the orchard (plate 2), that Adams became convinced of the importance of the wilderness.

In the tradition of Walt Whitman and Ralph Waldo Emerson, Adams believed in the spiritually redemptive power of the untouched landscape, feeling that human beings best understand their world and themselves if they see themselves in proportion with, rather than in opposition to, nature. In his numerous letters and articles supporting conservation efforts, Adams consistently identified the "intangible qualities" of the wilderness as those values that must be safeguarded for future generations. He not only promoted the ecological benefits of environmentalism but also stressed that people have a profoundly spiritual need for nature. It was this spiritual connection between the Earth and its inhabitants that Adams sought to express in his photographs and that he hoped would convince others of the necessity of preserving national parks. The Mural Project offered Adams the chance to pursue these goals on a greater scale than ever before: by creating wall-size images of the national parks, he would share the beauty of the American land with the public while promoting conservation and exploring new technical and thematic approaches to his art.

By the time Adams signed his contract with the Interior Department and headed toward Arizona's Grand Canyon National Park, 1941 had already been a landmark year for him. On New Year's Eve, 1940, the first department of photography at a fine-arts institution had opened at the Museum of Modern Art in New York, largely owing to the efforts of Adams, curator and writer Beaumont Newhall, and philanthropist David McAlpin. Back in California, while teaching at the Art Center School in Los Angeles, Adams developed the "Zone System," a revolutionary method of regulating the exposure and development of negatives in order to maximize the photographer's control of the final printed image. According to the Zone System, light is divided into

eleven zones (zero is pure black, medium gray is five, and white is ten). After determining the range of contrast in the subject, the photographer assigns the areas of light and dark in the image to the appropriate zones and then exposes and develops the film according to the desired intensity of tone. This technical innovation, now a staple of photography, facilitated Adams's aesthetic practice, which he termed "visualization." The basic component of Adams's "expressive photography," visualization requires the photographer to capture his response to a particular scene, not simply reproduce the landscape before him. The fall of light, the play of shadows, the line of the horizon, the angle of a tree line or rock formation, should all express what the photographer feels about the view. Adams's visualization was a working method derived from his beloved mentor Alfred Stieglitz's credo that photographs are the visual equivalents of emotion and perception.

The Zone System simplified and codified the technical steps necessary for the manipulation of light and shadow in a visualized image, and Adams used this system skillfully in the photographs he took for the Mural Project. The dark ravines in Adams's views of the Grand Canyon (plates 20, 23, 29) have been rendered fathomless and awe-inspiring by the photographer's own vision of how he saw—or rather interpreted—these massive, curving forms stretching out to a rocky horizon. Adams photographed certain areas over and over again, changing position, lens, or filter, or sometimes altering the horizon or the shadows only slightly, striving to capture the exact image (or images) in his mind. In his close-ups of the Grand Canyon, the ravines and rocks become almost abstract studies (plates 24–26); Adams was less interested in verisimilitude than in focusing on his own reactions to the world around him. The Mural Project photographs include several examples of nearly identical views of the same subject, suggesting both the depth of Adams's response to these landscapes and his driving desire to fully document his vision. The dynamic, towering white sprays of water in the Old Faithful Geyser series (plates 101–6) are at once incisive studies of a natural phenomenon at work, a photo essay on the modulations of light (the photographs were taken at various intervals at dawn and dusk), and an abstract rendering of a kinetic vertical form.

Adams's manipulation of light and tonal values produced some especially dramatic cloud-covered mountainscapes of Grand Teton National Park (plates 85, 87–92), Rocky Mountain National Park (plates 82–84), and Glacier National Park (plates 116, 122–23). In

"Near Teton National Park" (plate 91) and "In Rocky Mountain National Park" (plate 84) thick, dark-shadowed clouds dominate the scene, stretching from foreground to background, pressing down on the landscape below. The enveloping blanket of clouds and fog in "In Glacier National Park" (plate 122) brings the viewer into immediate contact with the mountain range, heightening the viewer's sense of being deeply connected to the land, the sky, and the elements. Clouds serve as effective backdrops in Adams's sweeping panoramas, such as his well-known "The Tetons—Snake River" (plate 85) and his views of St. Mary's Lake (plate 123), Logan Pass (plate 119), McDonald Lake (plates 113, 124), and Two Medicine Lake (plate 120) in Glacier National Park. In these images, clouds fill out the horizon, complement snow-covered peaks, or balance shimmering water in the foreground. Light behind the clouds either softly illuminates the scene (plate 124) or pierces through the shadows in brilliant rays (plate 85), and the mountains' rocky crags, the trees' bristling branches, and the water's rippling surface are all carefully delineated, forming a rich tapestry of textures. In these photographs each element is uniquely rendered and balanced within the whole, just as in music (as Adams might say) each note in a perfect chord is played with distinctive accuracy to achieve a harmonious overall sound.

Such astounding detail was imperative in Adams's panoramic views, for he believed that a photograph must be as "straight" as it is expressive. In 1932 Adams was one of the founders of the California-based f/64, a group of photographers that also included Edward Weston and Imogen Cunningham, who united to resist the prevailing pictorialist tradition in photography. The group took its name from the smallest aperture setting on the camera lens, the one that allows the greatest depth of field and thereby provides for extremely sharp detail in the final print. Adams and his f/64 peers wanted to create clear, straight photographs that resembled photographs, not the soft-focus images the pictorialists made, which tried to approximate the painterly effects of drawings or etchings. As true modernists, the f/64 photographers believed that no artwork should be modeled on or copied from the form of another, and therefore photographs should be evaluated solely within the terms of their own medium. Adams emphasized his commitment to "pure" photography in the proposal letter he sent to First Assistant Secretary Burlew at the Interior Department on August 10, 1941, when negotiations for the Mural Project were gaining momentum:

Negatives from which the murals will be made should all be of consistent quality. A unified aesthetic point of view is of the utmost importance. A photograph, because of its intense realism, must be completely accurate in mood and factual relationships. . . . Photo-murals, because of the obvious limitations of the medium of photography, must be simpler—either purely decorative (like the screen in Secretary Ickes's office) or forcefully interpretive. I do not believe in mere big scenic enlargements, which are usually shallow in content and become tiresome in time.

This devotion to accuracy is as evident in Adams's close-ups as it is in his larger views. Pictures of leaves (plate 117), ferns (plate 1), cactus (plate 52), and underground rock formations (plate 62) convey the same scientific precision and spiritual wonder that the expansive, endless landscapes offer. Adams believed passionately in a reflexive relationship between the Earth's micro- and macrocosms—that all the marvels of creation are mirrored in its smallest elements; a single leaf or a tiny fragment of terrain illuminates the glories of nature as wondrously as the whole range of the Sierra Nevada.

The Mural Project gave Adams the chance to expand on another of his favorite themes, man in relation to nature. In Colorado, Arizona, and New Mexico, Adams photographed the villages and ancient settlements of the Native Americans, illustrating, in part, how the Indians have lived in harmony with the environment. His photograph of the Canyon de Chelly (plate 34) shows the remains of an Anasazi village literally growing out of a stone cliff and nestled against a protective wall of streaked rock that curves gracefully, forcefully skyward. Abundant foliage fills a portion of the foreground, underscoring the organic connection between this past civilization and its ecosystem. The cliff dwellings in Mesa Verde National Park (plates 35–37) are also seen as part of their mountainous environment; the simple rounded and rectangular towers dotted with windows look as ageless and inimitable as the rocky peaks and ravines near which they were built. In Adams's photographs of the Indian villages at Walpi, Arizona (plate 44), and Acoma Pueblo, New Mexico (plate 68), the shadows cast by the buildings blend into the lines of the earth and rocks, and the crosses and towers reach into the sky, suggesting that the man-made is thoroughly integrated into the realm of nature.

Adams's photographs of freestanding buildings, such as "Church at Taos" (plates 38, 40), and his figure studies of the Indians (the few examples of Adams's talent as a portraitist that are included in this body of work) also indicate the photographer's respect for the Indian way of life. Often, the subject is photographed from below, as in the portrait of an Indian woman with children (plate 33) and in the photographs of a tribal dance at San Ildefonso Pueblo (plates 41–42); the viewer is being invited into the Indians' space, from a distance. The Native American communities portrayed in these images are living close to the land, within their natural means, as Adams felt we all should. A member of the board of directors of the Sierra Club from 1934 to 1971, Adams joined—and often led—conservationists' efforts to combat exploitation of resources and environmental abuses. His photographs of the orderly plowed and planted fields of Tuba City, Arizona (plate 45), and of sheep grazing peacefully on a hillside in Owens Valley, California (plate 46), demonstrate the harmony among people, animals, and the land that he espoused.

Adams was also a pragmatist, and he recognized the needs of twentieth-century society. As part of the Mural Project he photographed the power unit at Boulder Dam, Colorado, capturing the immense technology at work from an artist's perspective. Seen at close range, the soaring architecture of cones, tubes, rectangles, and lines (plates 68–69) recalls the photographs of skyscrapers that many of Adams's urban counterparts, such as Berenice Abbott, were taking in metropolitan areas about the same time. When photographing the power unit in its mountain landscape (plates 67, 70–71), Adams could not resist heightening the drama of the natural scene by rendering the mountains an almost impenetrable black, the sky filled with shadowy clouds. The range of contrast in these and so many of the Mural Project images reveals the artist's superb sensibility; his photographs translate black, gray, and white into a full spectrum of vivid tones.

As a proponent of what he termed "appropriate use" of public lands, Adams eagerly sought compromises or alternatives to the overdevelopment of the national parks. He vehemently opposed promoting the parks as recreational centers; those who were truly attuned to the values of the wilderness would visit them without commercial inducement to do so. In Adams's Mural Project photographs, visitors appear only in a few of his images of the stunning stalactites and stalagmites in Carlsbad Caverns. These people seem diminutive next to the massive,

bubbled rock formations lit with theatrical intensity in the underground darkness; they stare with quiet wonder at the mystery that surrounds them, itinerant travelers passing briefly through eternal Nature.

Society's potentially destructive intrusiveness into the wilderness is hinted at in only two of the Mural Project photographs: "Roaring Mountain, Yellowstone National Park" (plate 95) and "Burned Area, Glacier National Park" (plate 121). It is possible that these photographs are just records of natural phenomena, but the barren trees, many of them with charred, lifeless trunks, contrast eerily with the verdant hillsides and sparkling waters in Adams's other photographs of these parks. While images of damaged earth are common among today's landscape photographers, Adams's world represents an idealized American wilderness; through his eyes we see the national parks as protected refuges of nature. These two pictures were not the best candidates for the Interior Department's murals, but Adams was a thorough, tireless worker; he photographed nearly every vista along this historic journey.

Unfortunately, we will never know which of Adams's 225 Mural Project photographs would have decorated the walls of the Interior Department. His trip through Colorado, Wyoming, and Montana during the early summer of 1942 was his last foray into the national parks under the aegis of the government. The Mural Project was cancelled at the end of the 1941–42 fiscal year because of the country's escalating involvement in World War II following the Japanese attack on Pearl Harbor. Adams wanted very much to contribute to the war effort, and he attempted to convince the Interior Department that the Mural Project was a worthy, patriotic cause: "I believe my work relates most efficiently to an emotional presentation of 'what we are fighting for,'" he wrote to Assistant Secretary Burlew on December 28, 1941. Adams's efforts were futile, however, although the government did pay for developing all pictures taken by June 30, 1942. In November Adams sent 225 signed exhibition prints to the Interior Department; the negatives were put in a vault at Yosemite, where Adams intended to supervise the final printing of those selected as murals once the war was over and funds were available. But Ickes left office shortly after the war ended, and the Mural Project was never revived. In 1962 the prints were transferred from the files of the National Park Service at the Interior Department to the National Archives, where they are now kept. The whereabouts of the negatives is a mystery, however; they are missing from the Yosemite offices, and no trace of them has yet been found.

We can only speculate which view of Yellowstone's Jupiter Terrace, which rim of the Grand Canyon, which section of the Snake River's winding path would have been exhibited in Washington as wall-sized commemorations of the majestic, spectacular, and sublime aspects of the American West. Adams must have looked forward to printing on this large scale, as he had made relatively few murals: a wintry orchard scene in Yosemite (plate 2), which was exhibited at the 1935 San Diego State Fair, and a few folding mural-screens, such as the one bought by Secretary Ickes in 1937. We do know from Adams's proposal letter that he had definite ideas about what kind of images would be appropriate as murals, and he certainly succeeded in choosing subjects that fit his aesthetic criteria; the prints he submitted include striking "decorative" close-ups and profoundly "interpretive" landscapes.

Although the Mural Project was short-lived, it shaped Adams's ensuing career and enduring reputation. Determined to continue photographing the national parks and monuments, Adams kept traveling across the country. In 1946 he received the first of two grants from the Guggenheim Foundation, and he used them to photograph America's protected wilderness areas from Maine to Alaska. His pictures of the national parks are arguably his most famous; today American audiences identify Ansel Adams as the legendary photographer who immortalized our natural heritage with untempered reverence. The Mural Project was the genesis of this achievement.

It is increasingly difficult to recognize Adams's America in our own surroundings; the Earth has been subjected to much greater development and defilement since these almost Edenic images were made. Inspired by Ansel Adams's prophetic vision of a world well worth preserving, perhaps we may yet see the fate of our civilization mirrored in what remains of our treasured wilderness.

ALICE GRAY

NOTE: *Caption text within quotation marks was taken from the reverse of the mount boards of the original prints.*

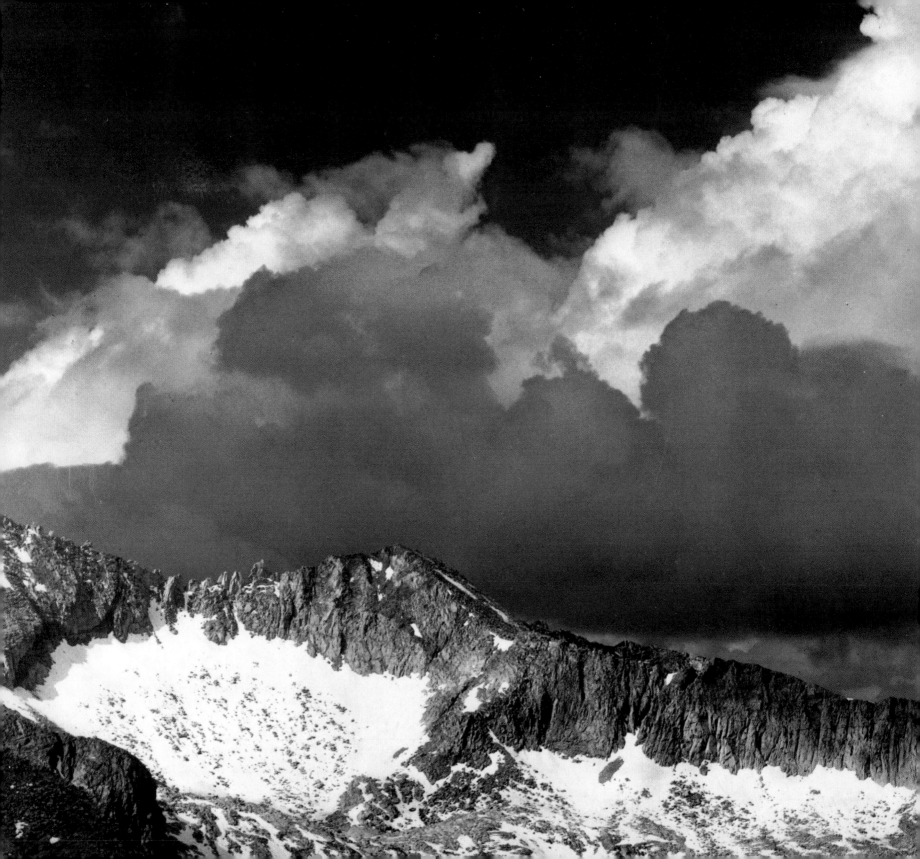

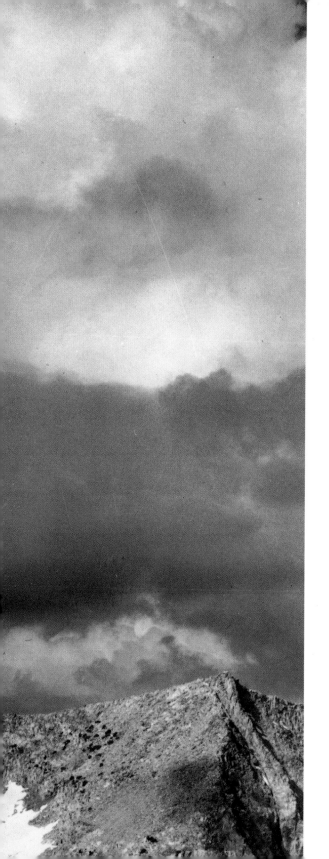

KINGS RIVER CANYON

California

4. "Clouds—White Pass"

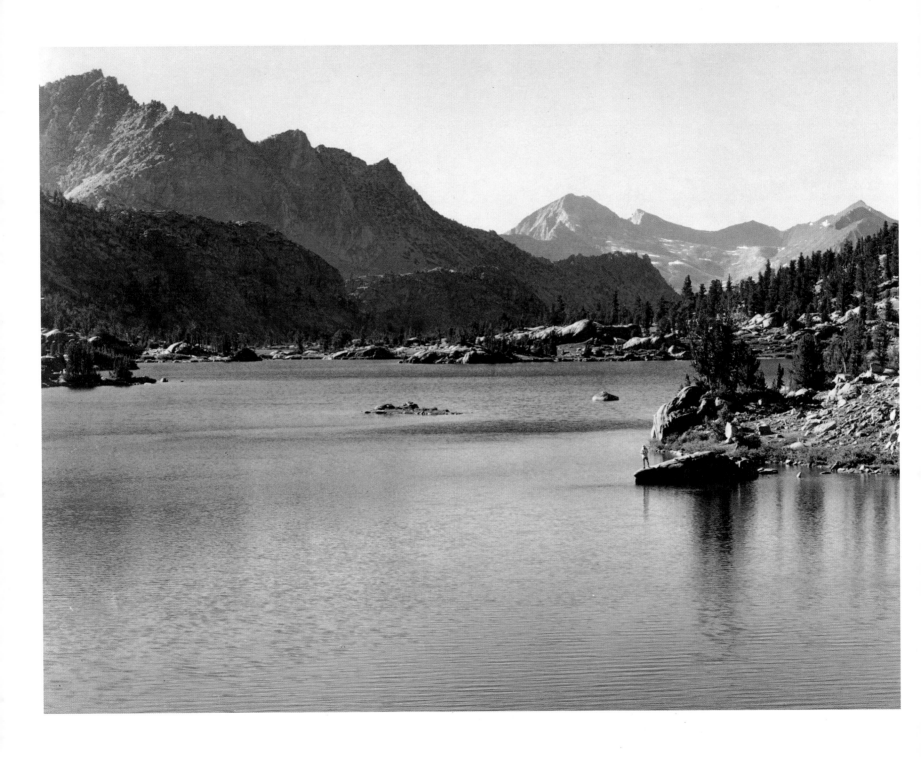

5. "Rae Lake"

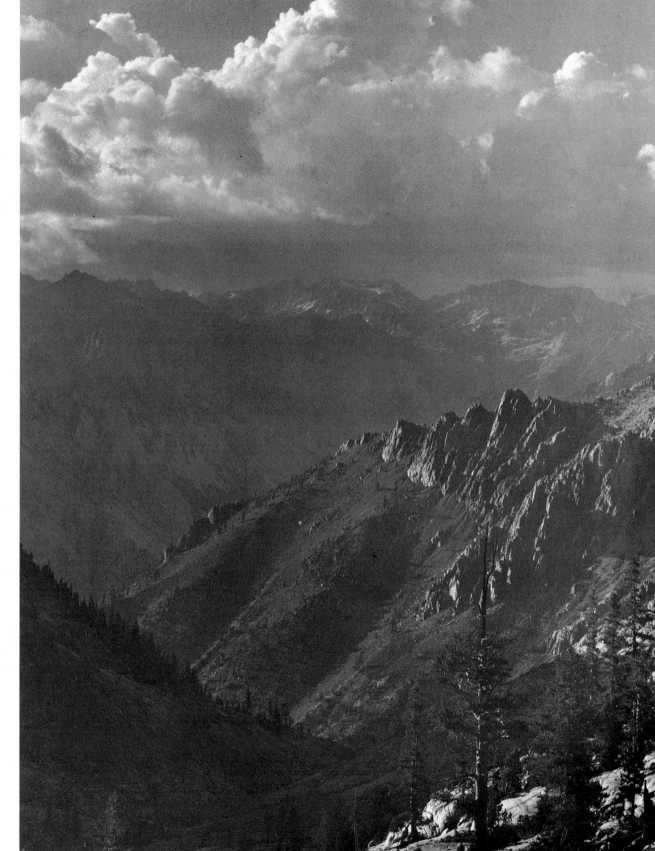

6. "Middle Fork at Kings River from
South Fork of Cartridge Creek"

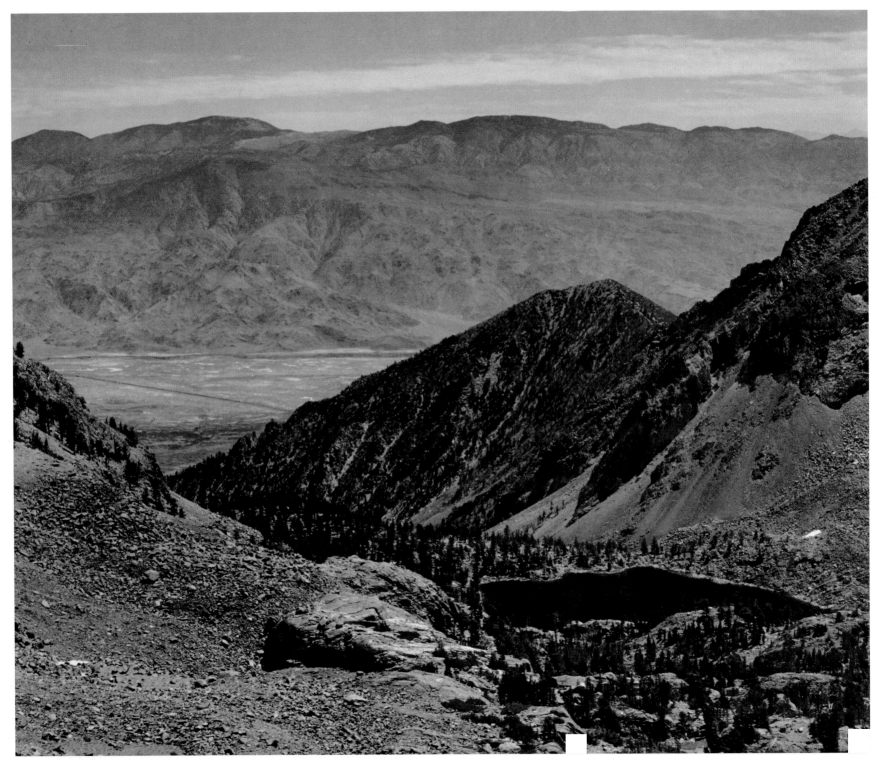

7. "Owens Valley from Sawmill Pass"

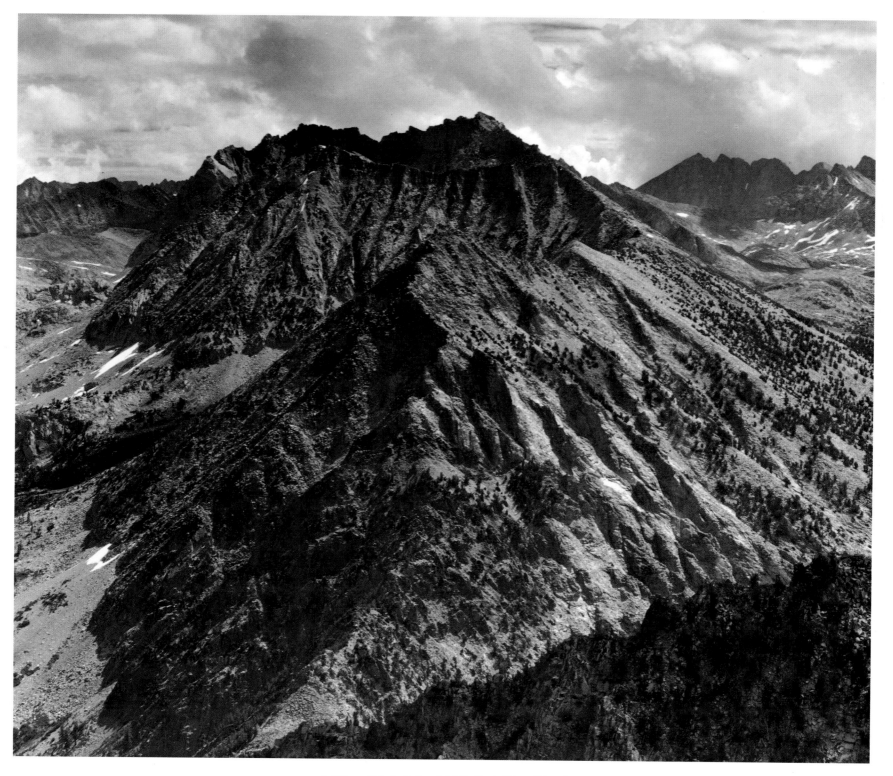

8. "From Windy Point, Middle Fork, Kings River"

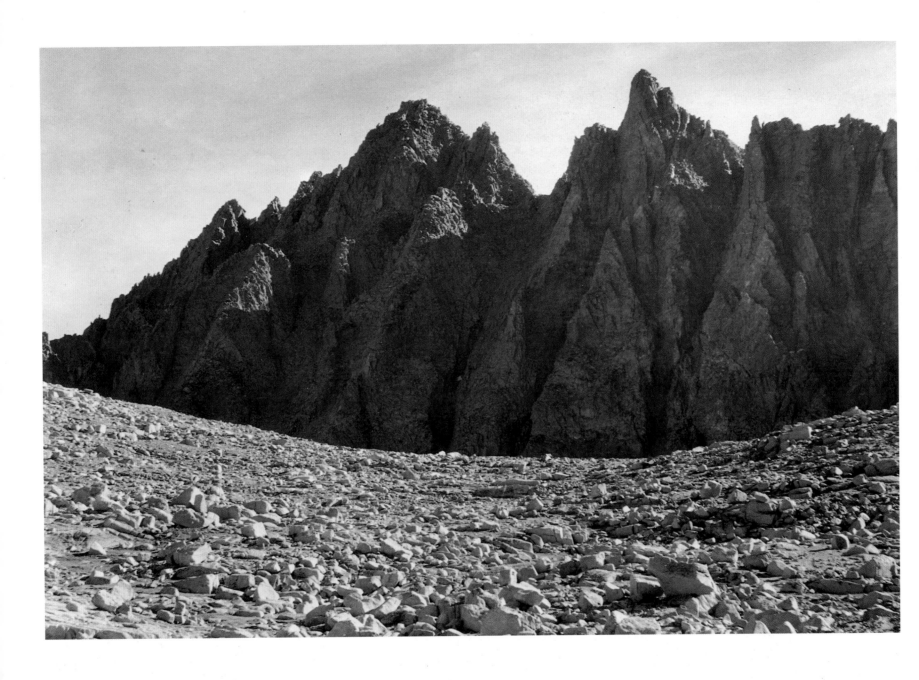

9. "Bishop Pass"

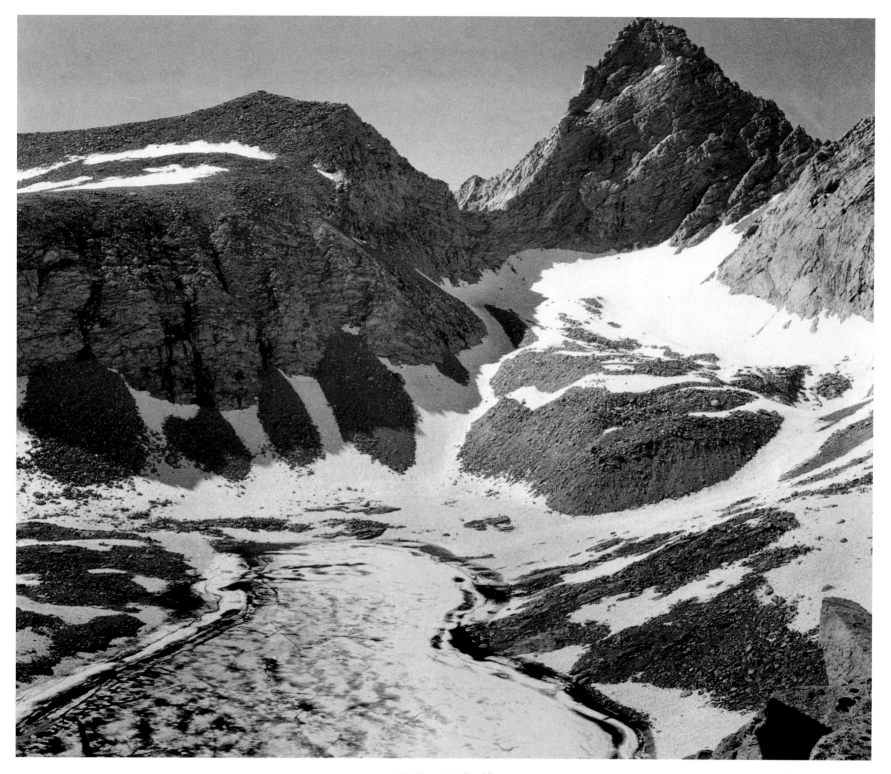

10. "Junction Peak"

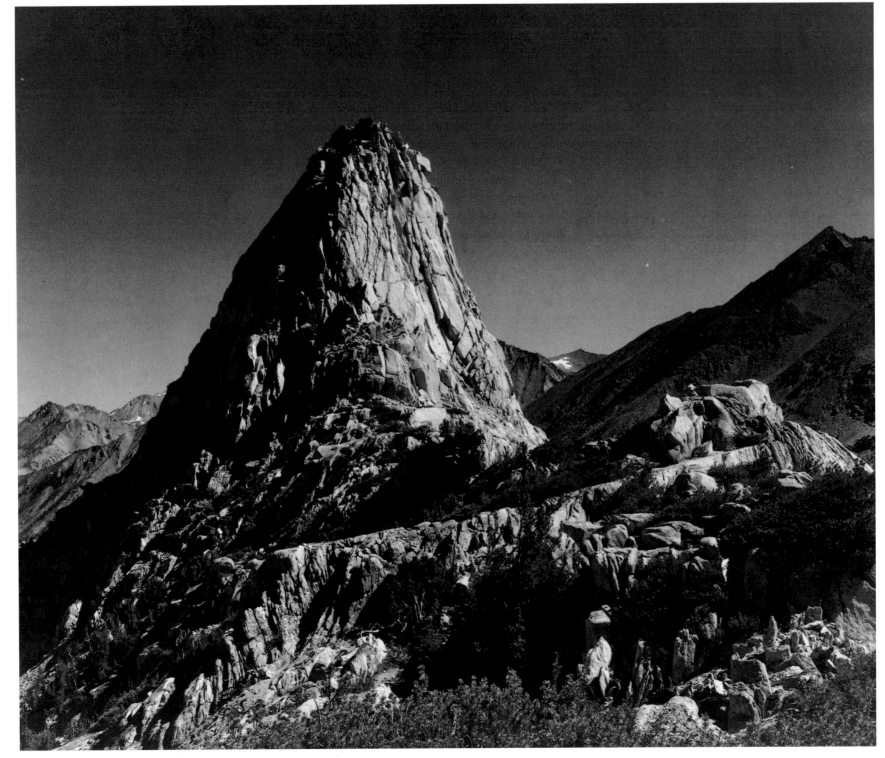

11. "Fin Dome"

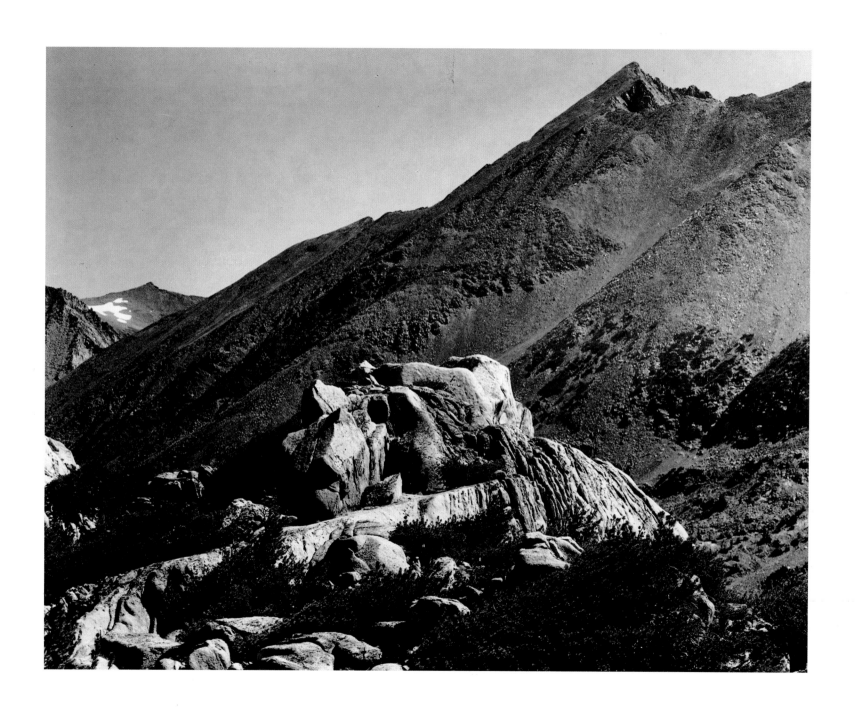

12. "Peak near Rac Lake"

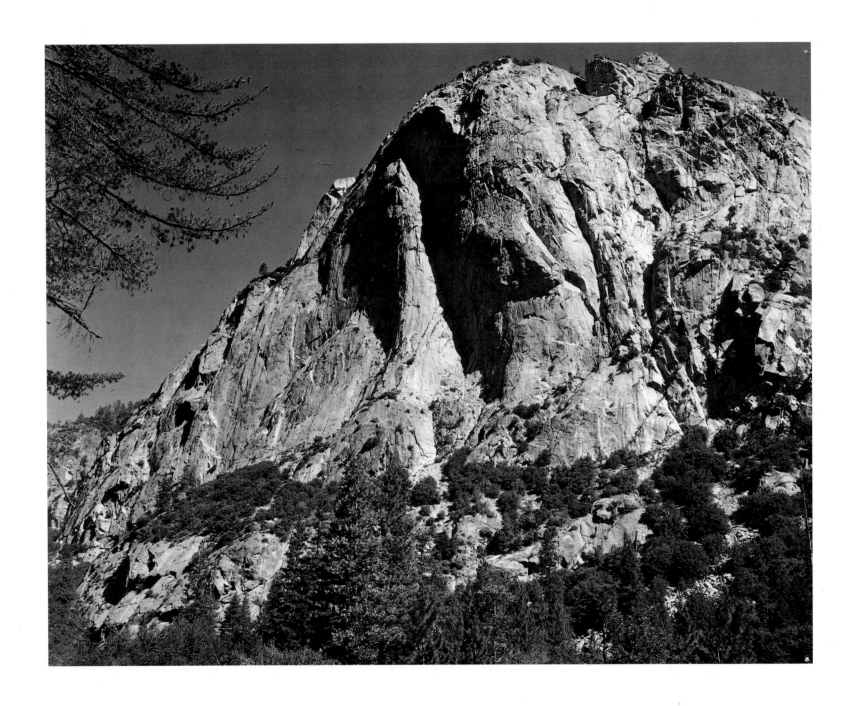

13. "North Dome, Kings River Canyon"

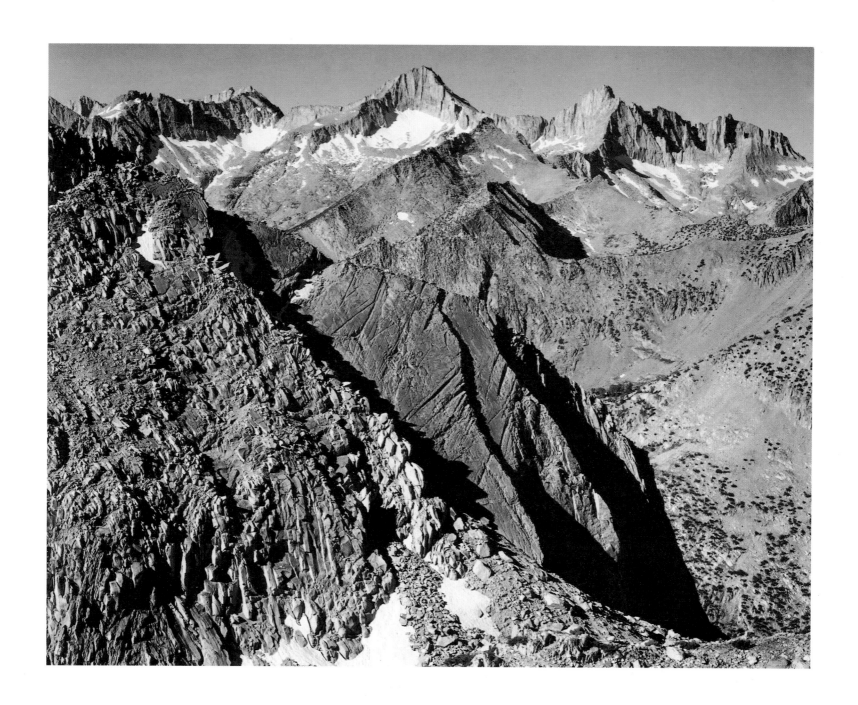

14. "Mt. Brewer"

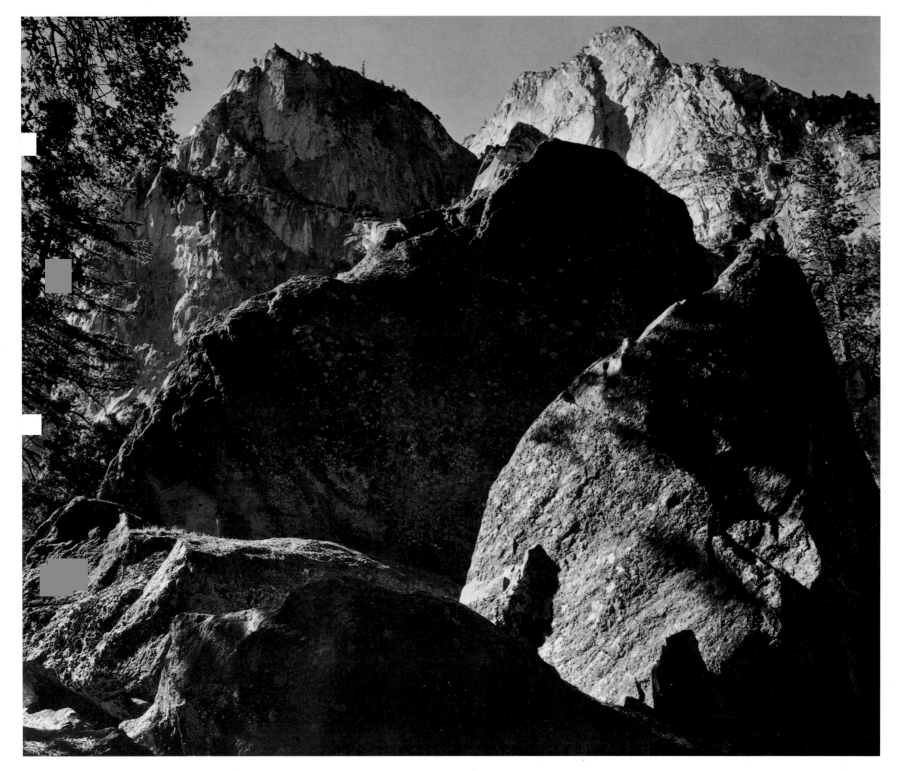

15. "Grand Sentinel"

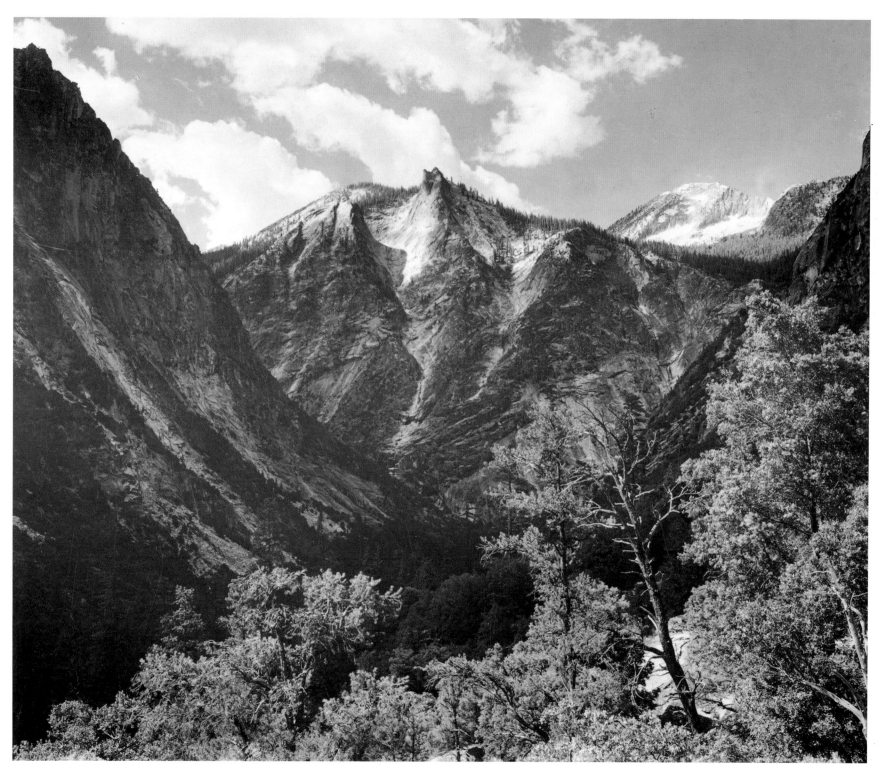

16. "Paradise Valley"

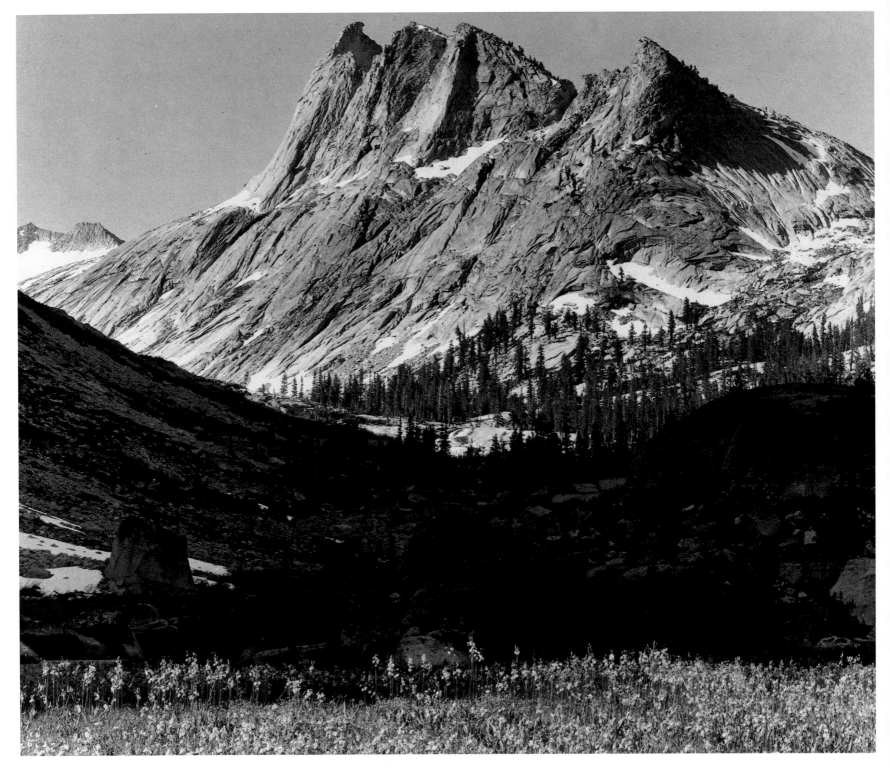

17. "Boaring River, Kings Region"

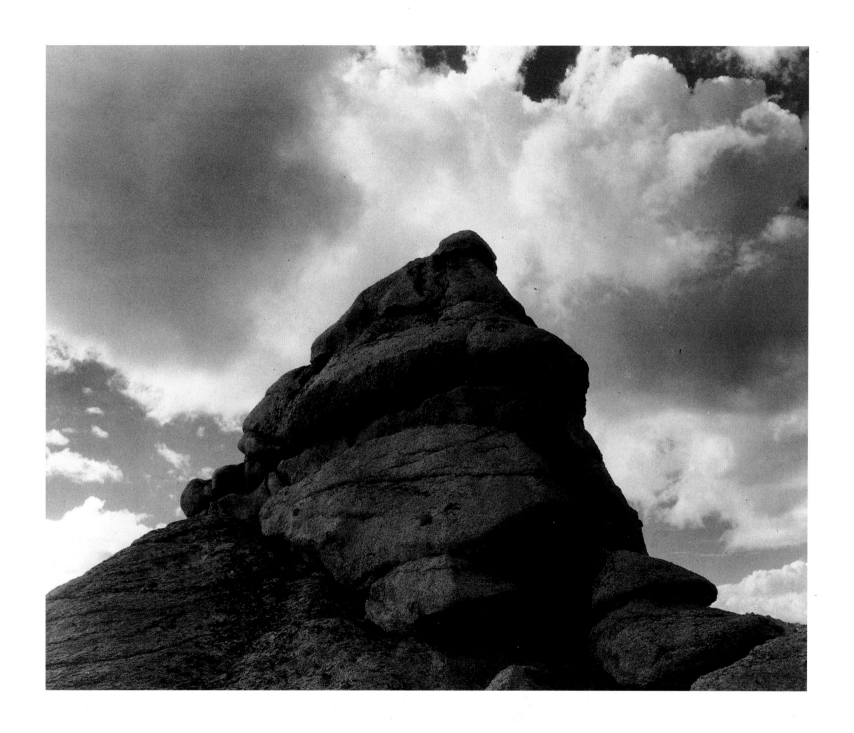

18. "Rock and Cloud"

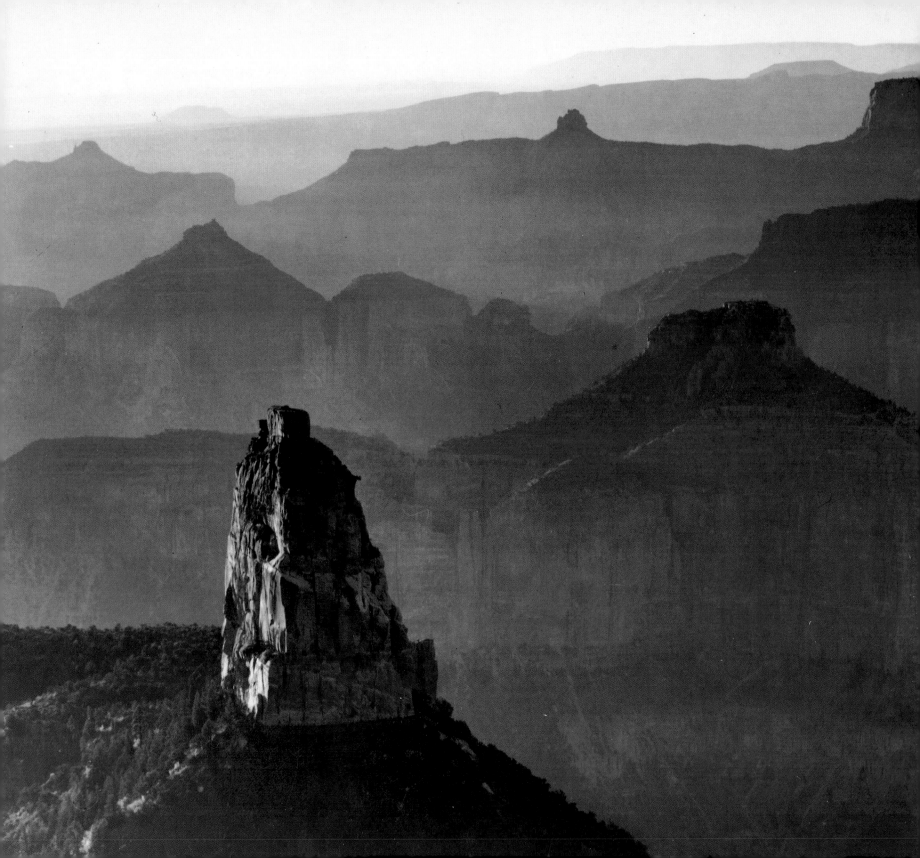

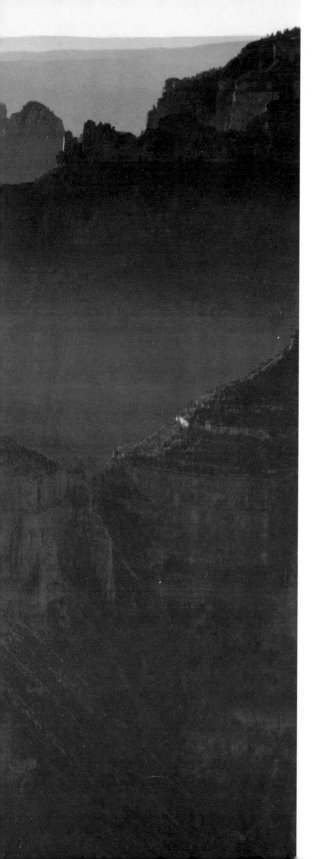

GRAND CANYON NATIONAL PARK

Arizona

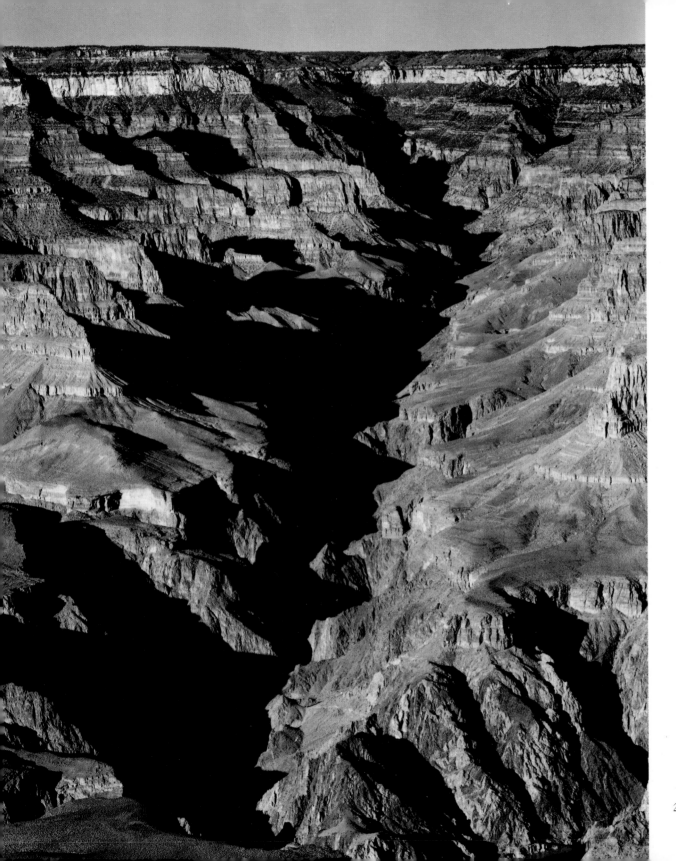

20. "Grand Canyon from South Rim, 1941"

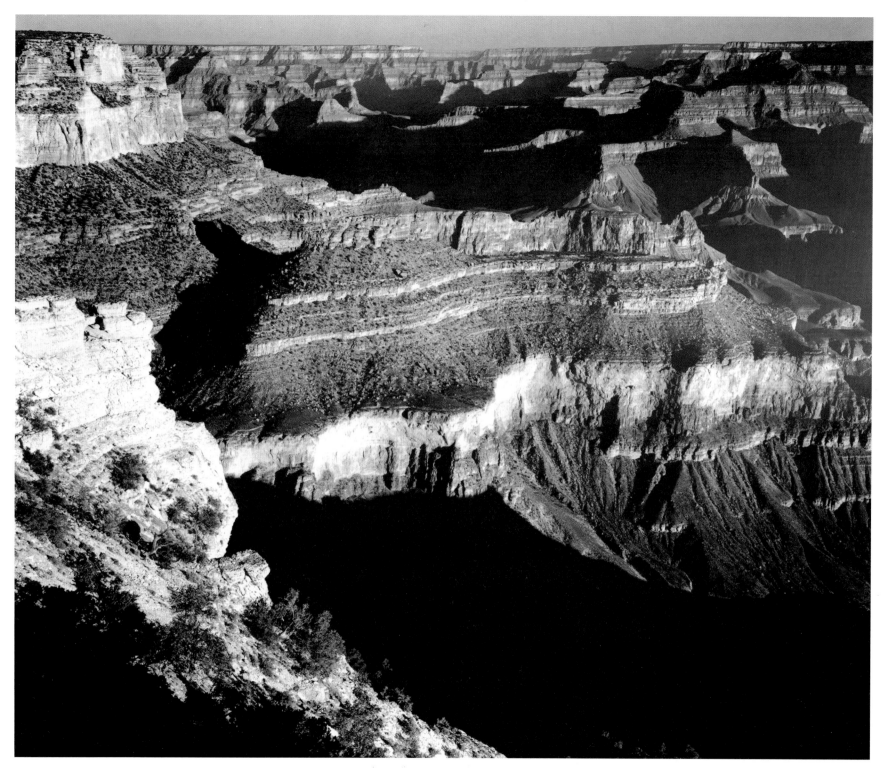

21. "Grand Canyon National Park"

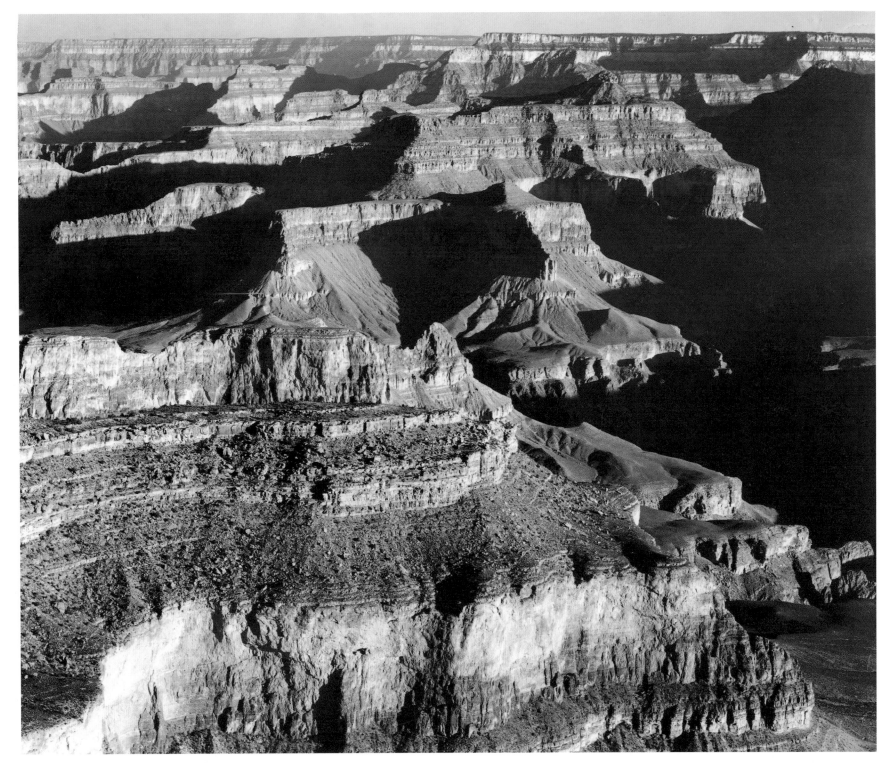

22. "Grand Canyon National Park"

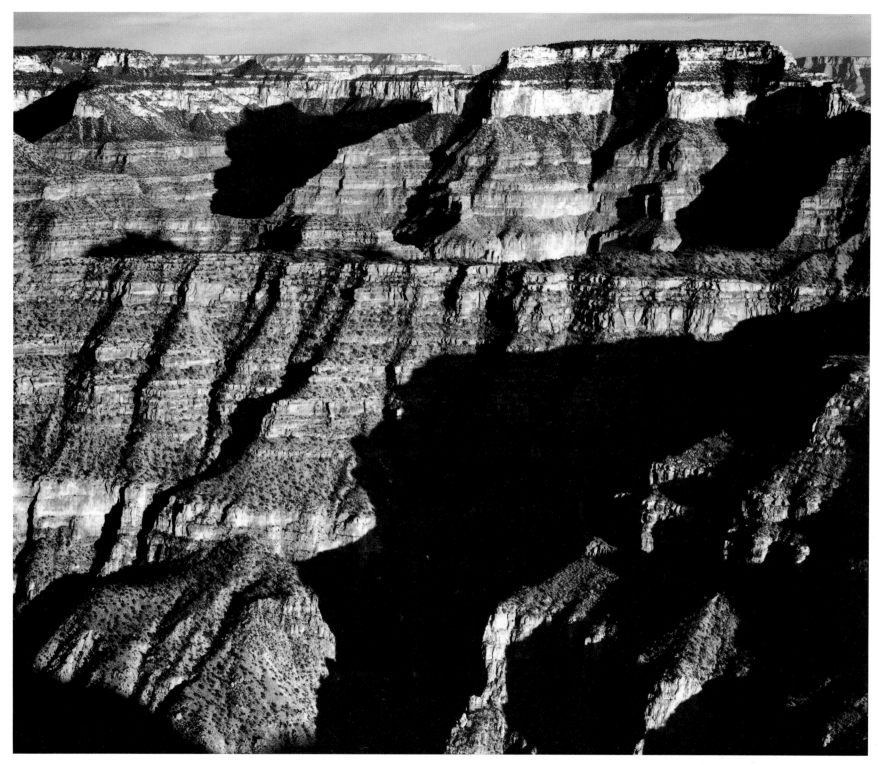

23. "Grand Canyon from North Rim, 1941"

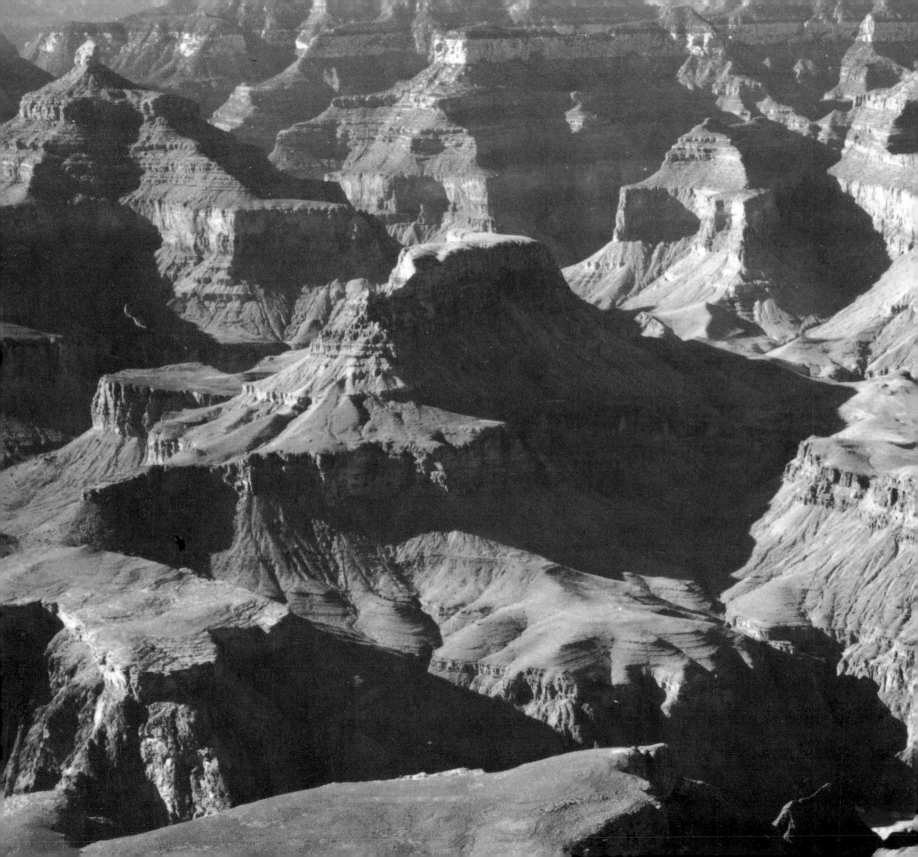

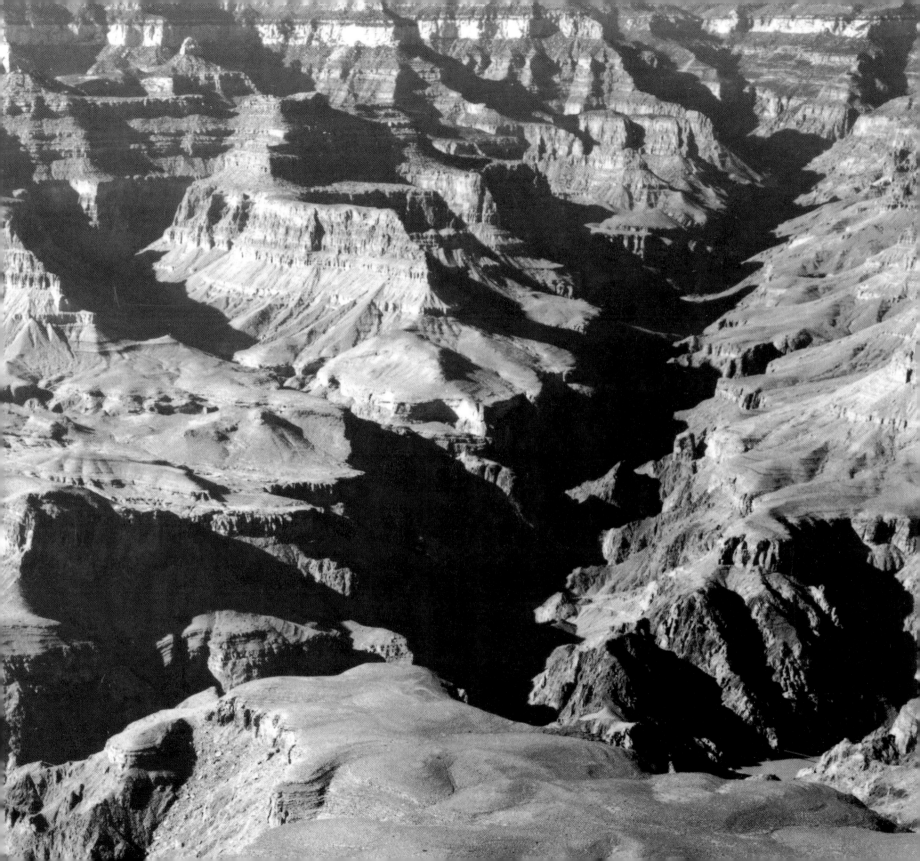

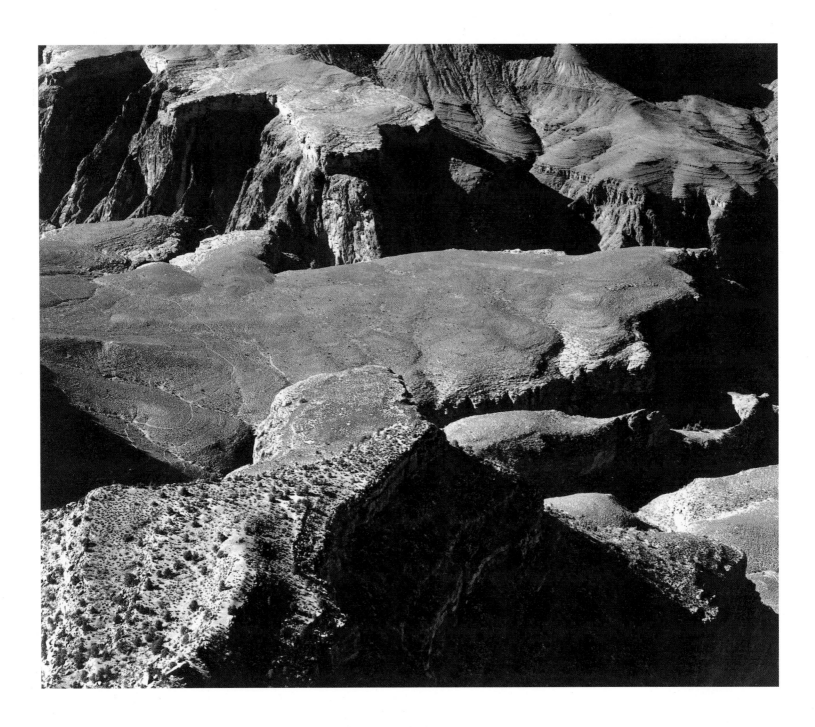

PRECEDING PAGES: 24. "Grand Canyon National Park" (detail)

ABOVE: 25. "Grand Canyon National Park"

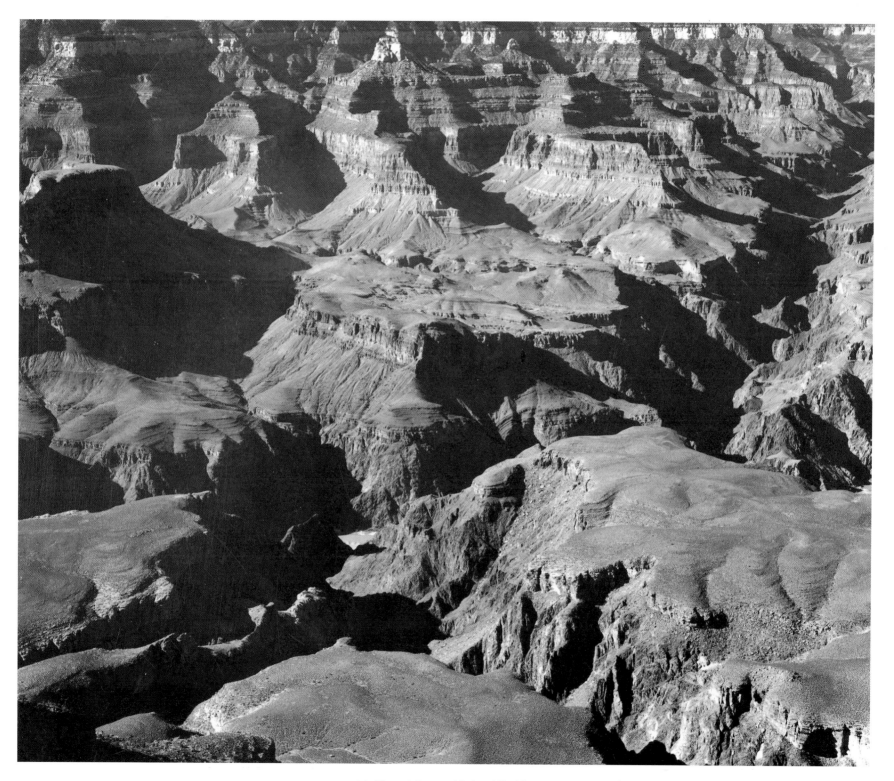

26. "Grand Canyon National Park"

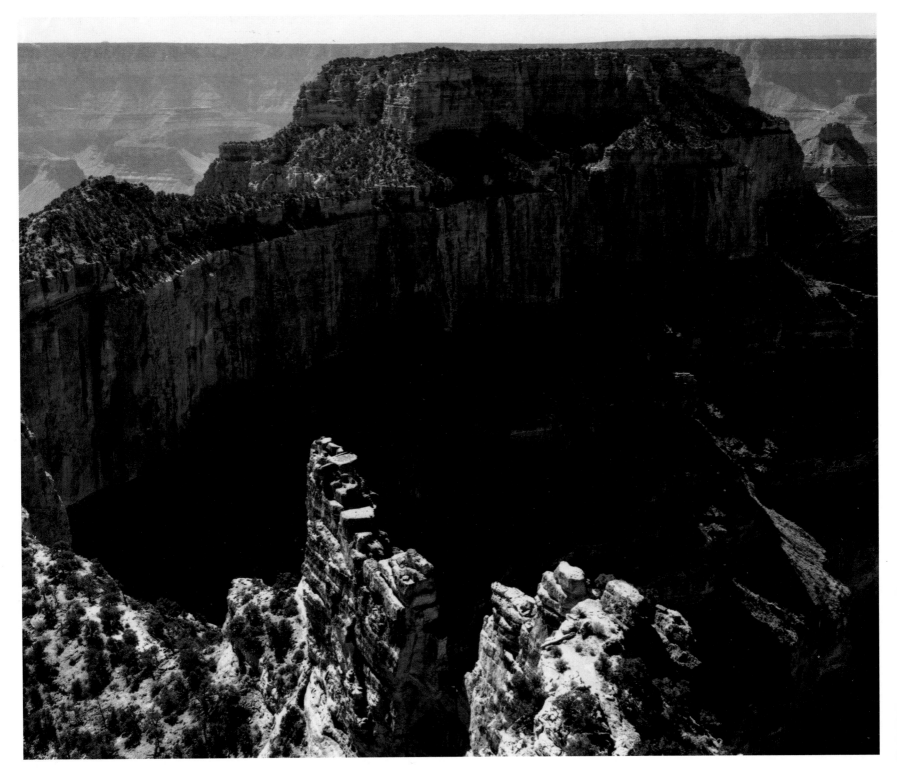

27. "Grand Canyon National Park"

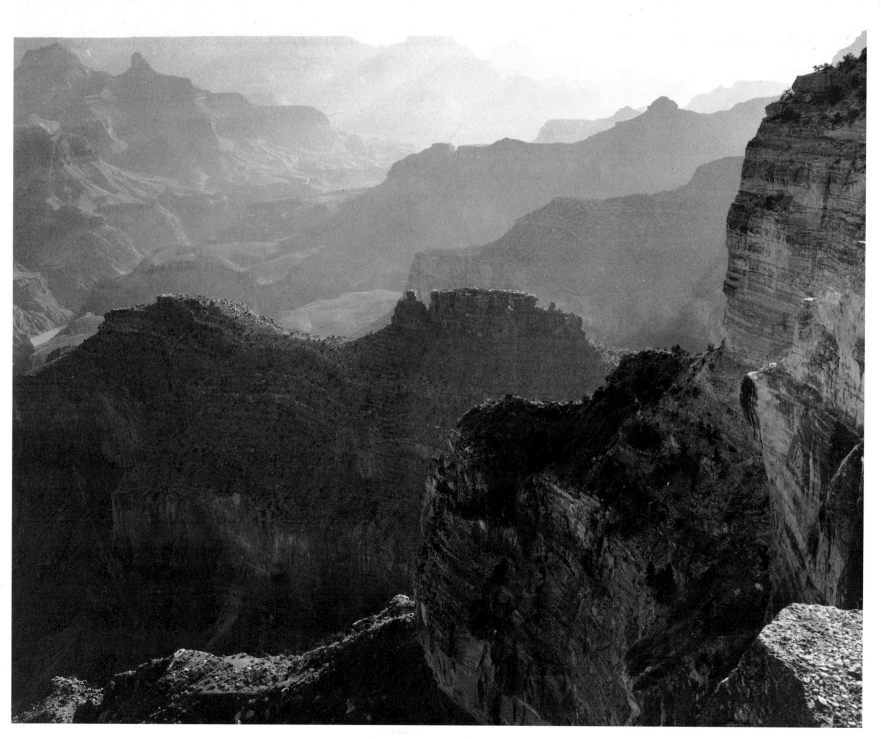

28. "Grand Canyon National Park"

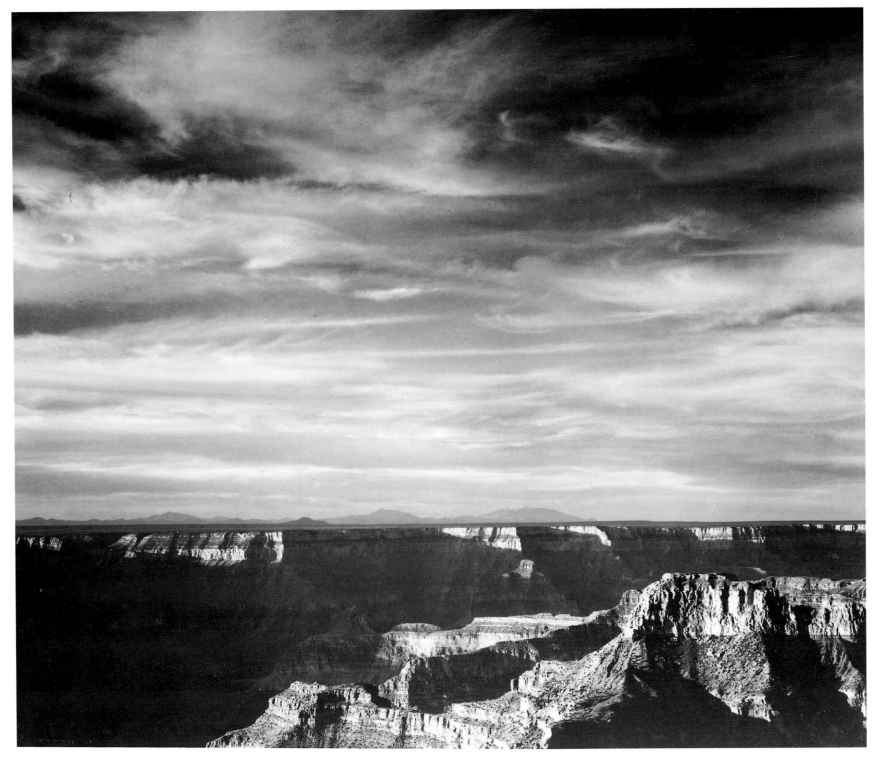

29. "Grand Canyon from North Rim, 1941"

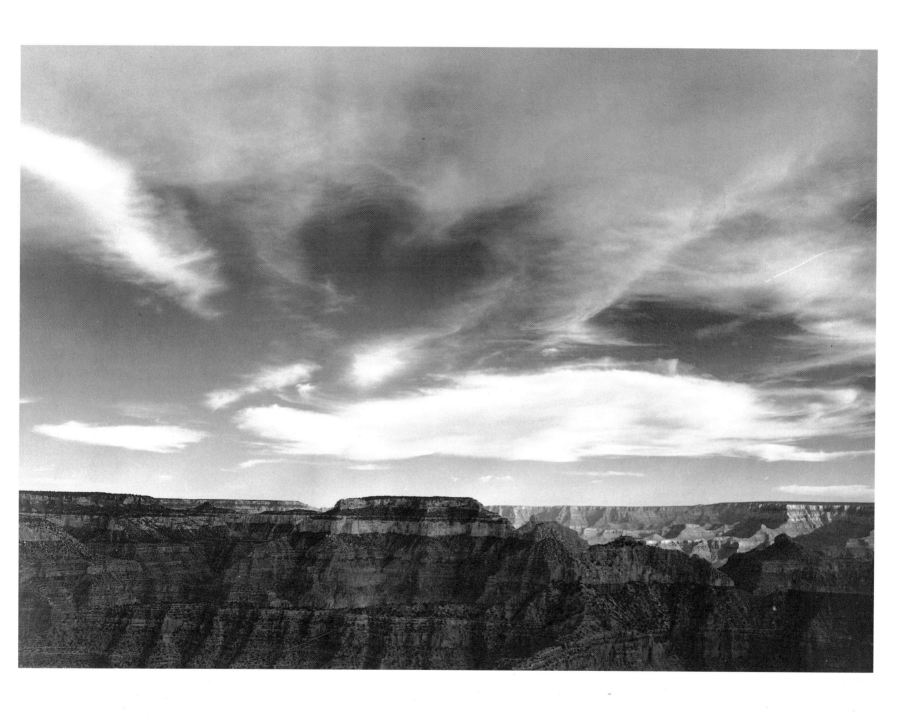

ABOVE: 30. "Grand Canyon National Park"
OVERLEAF: 31. "Grand Canyon National Park" (detail)

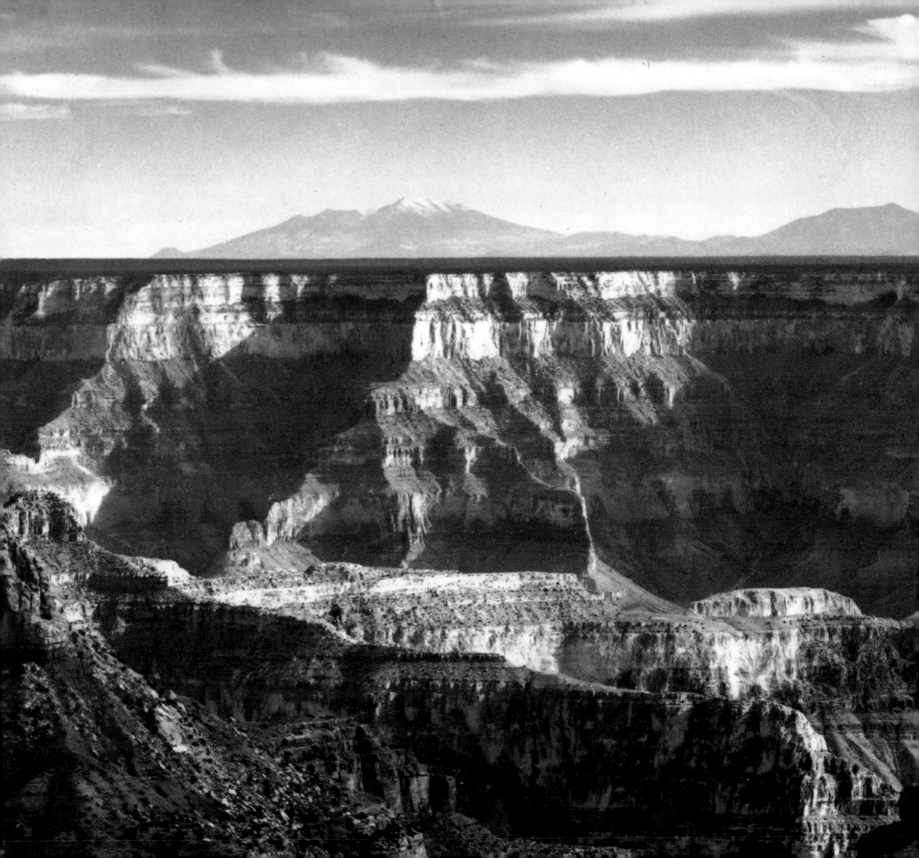

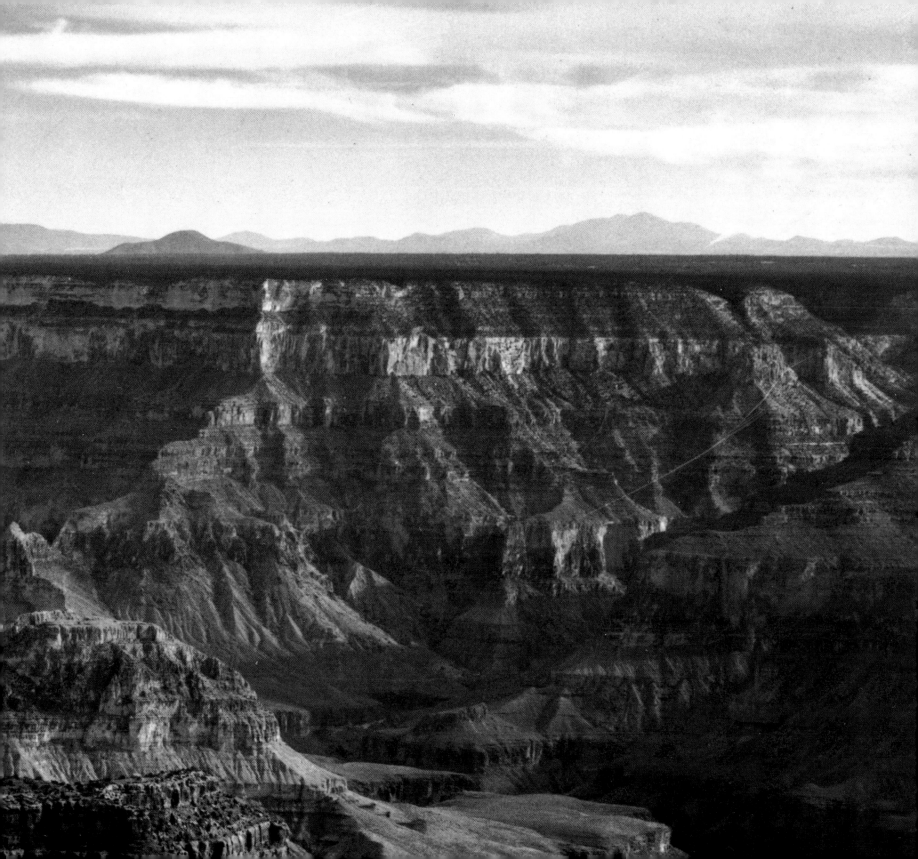

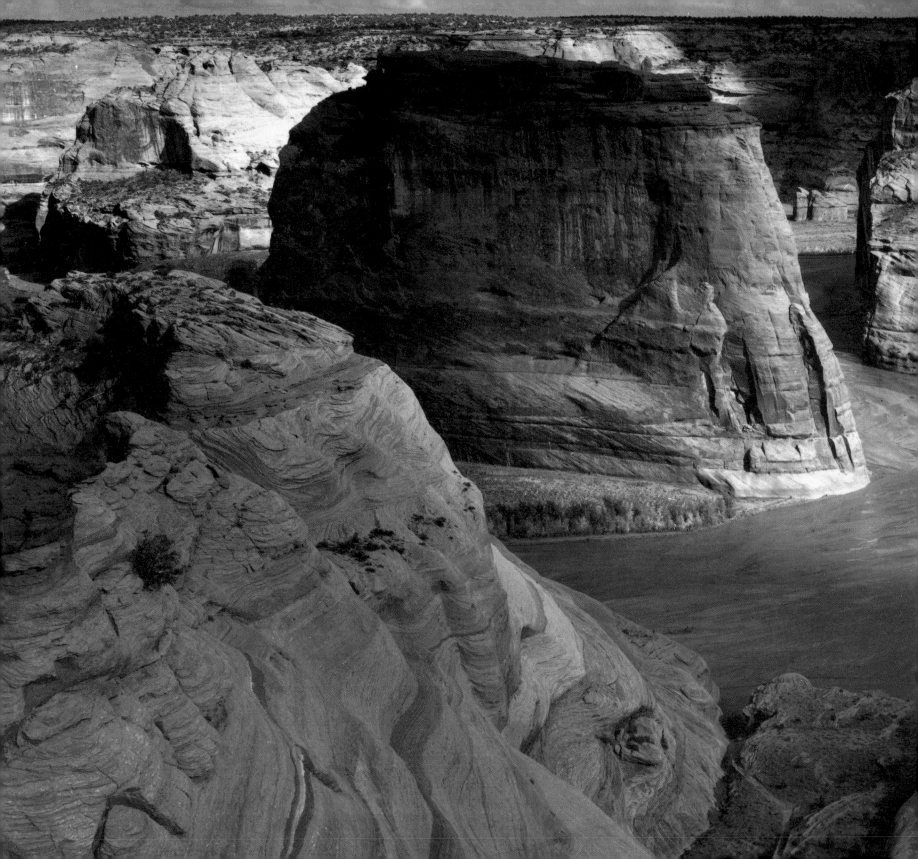

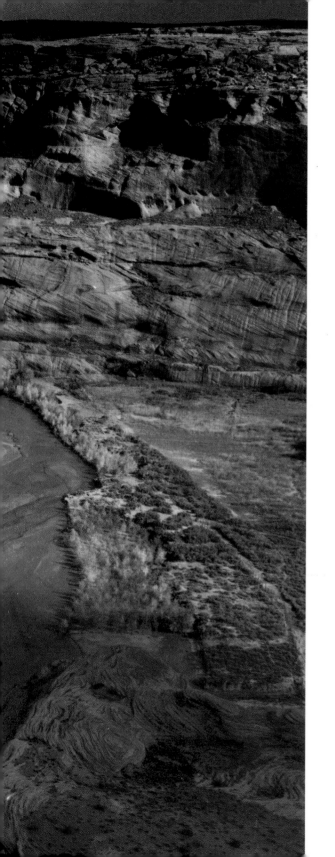

NATIVE AMERICANS
AND THEIR LANDS

32. "Canyon de Chelly"

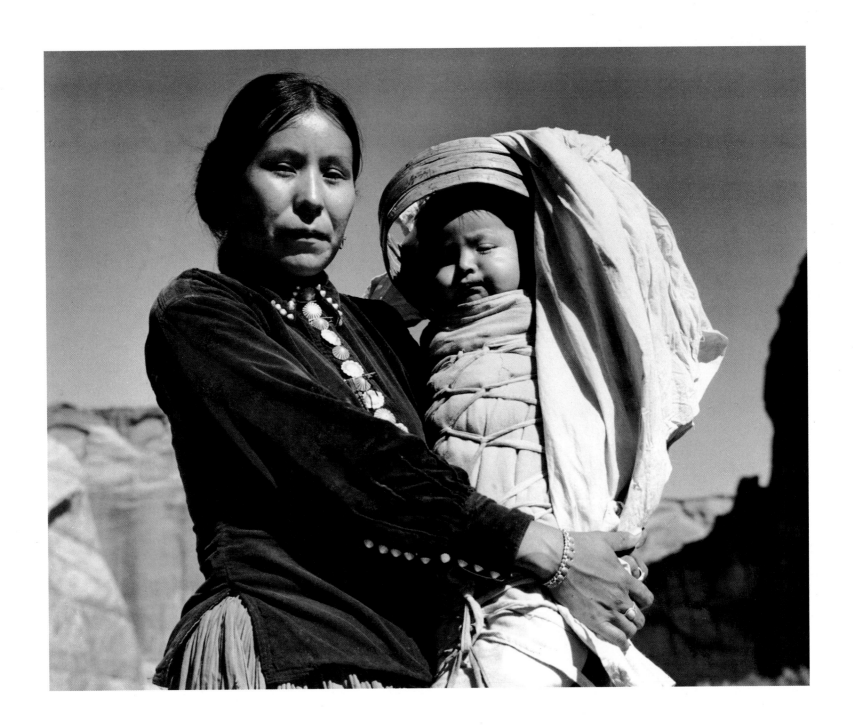

33. "Navajo Woman and Infant, Canyon de Chelly, Arizona"

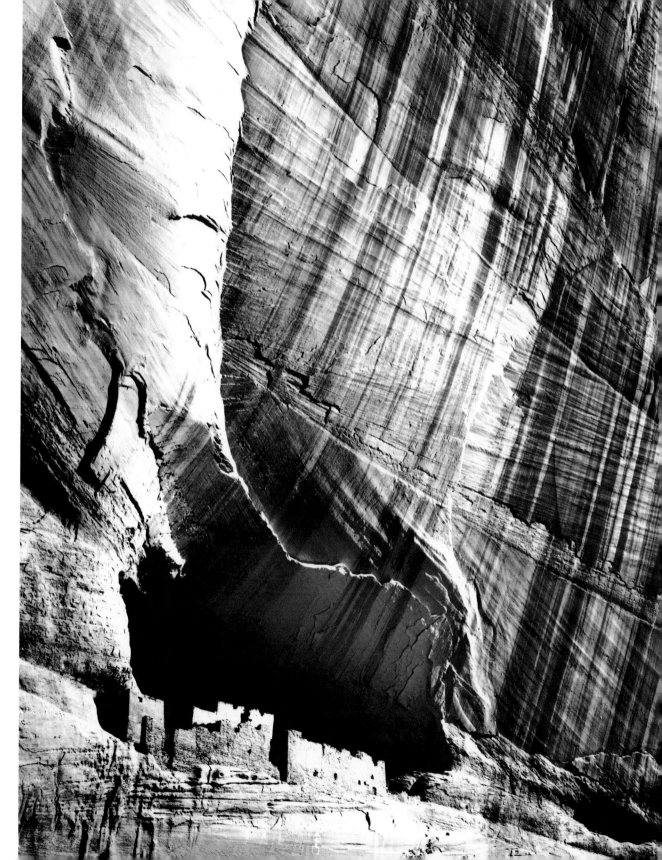

34. "Canyon de Chelly," Arizona

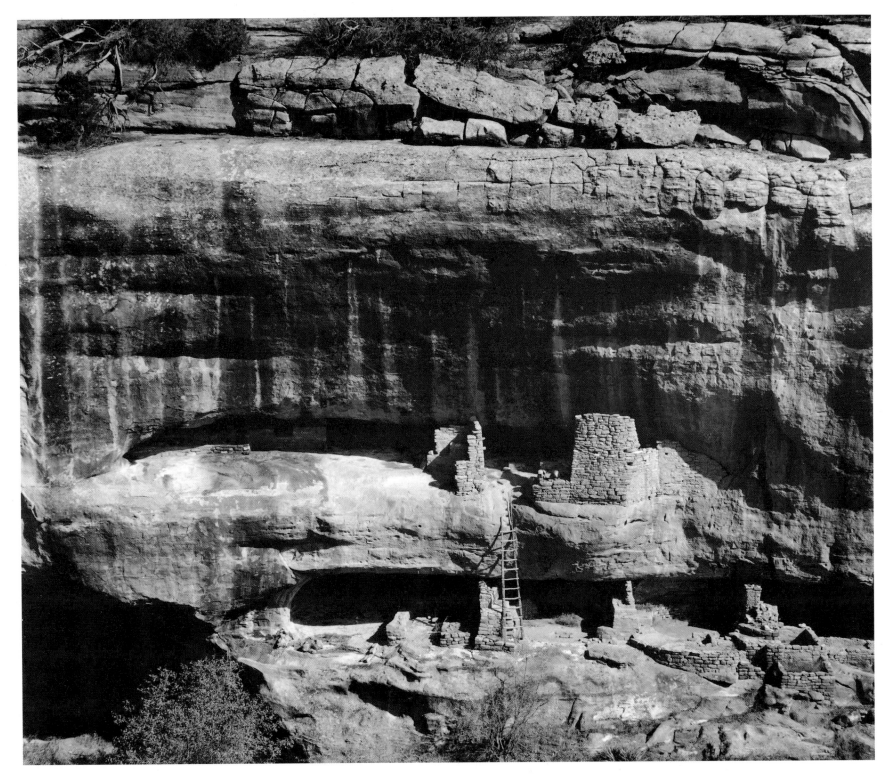

35. "Mesa Verde National Park, 1941," Colorado

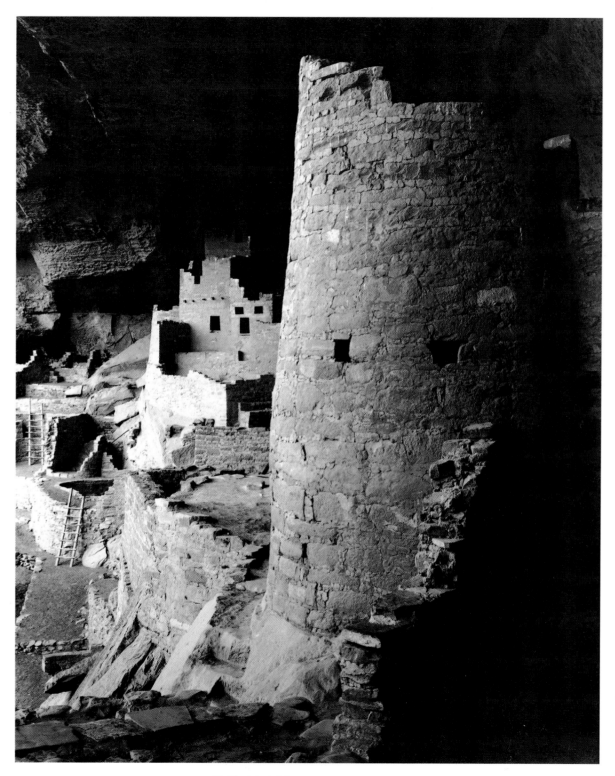

36. Untitled, Mesa Verde National Park

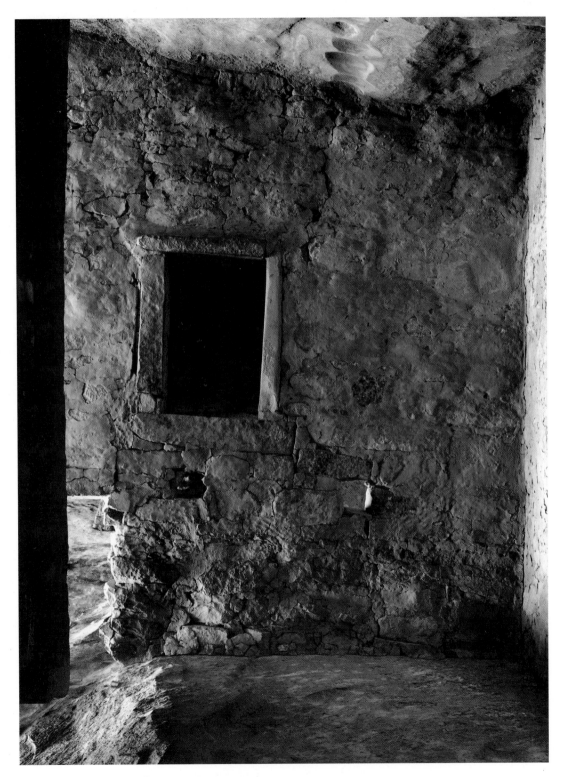

37. "Interior at Ruin Cliff Palace, Mesa Verde National Park, 1941"

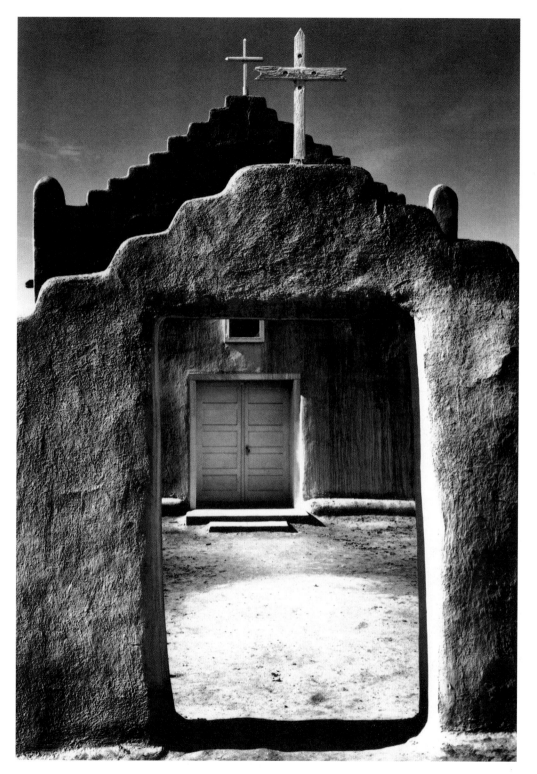

38. "Church, Taos Pueblo, New Mexico, 1942"

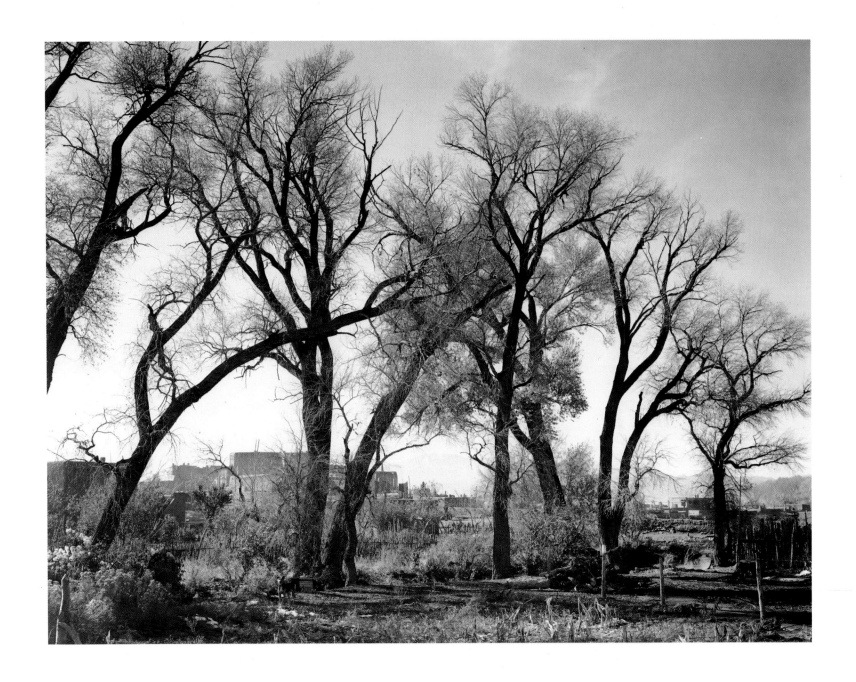

39. "At Taos Pueblo"

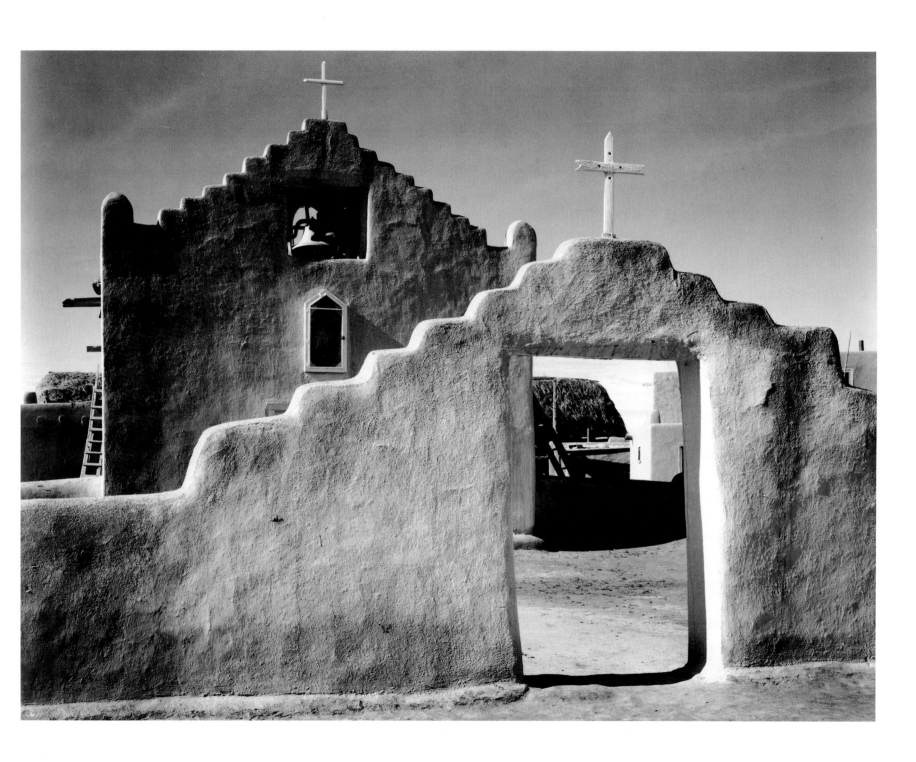

40. "Church, Taos Pueblo, New Mexico, 1941"

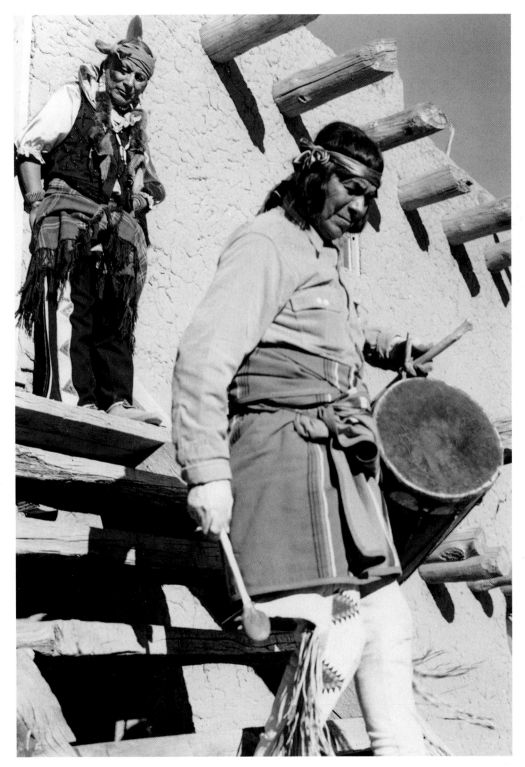

41. "Dance, San Ildefonso Pueblo, New Mexico, 1942"

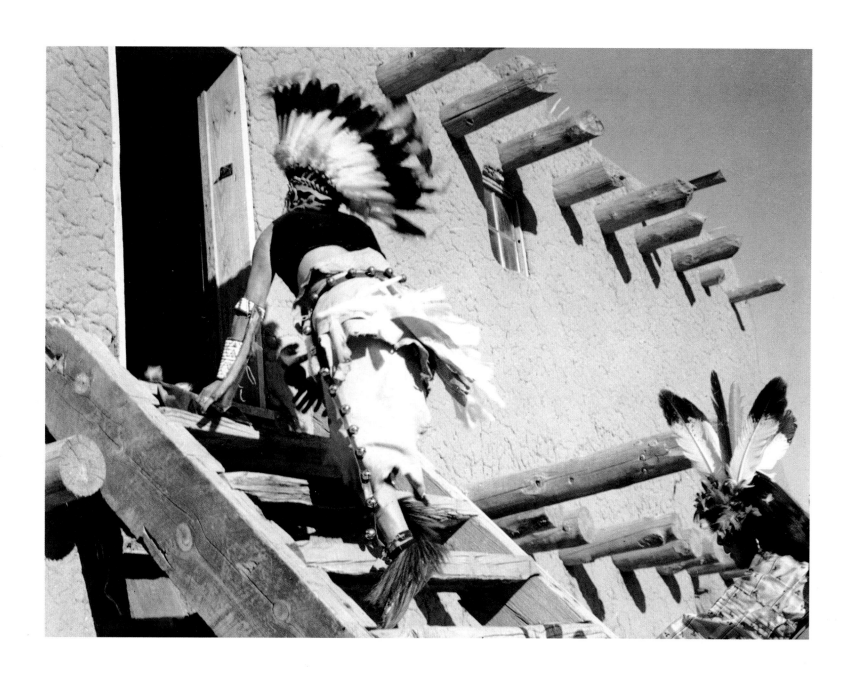

42. "Dance, San Ildefonso Pueblo, New Mexico, 1942"

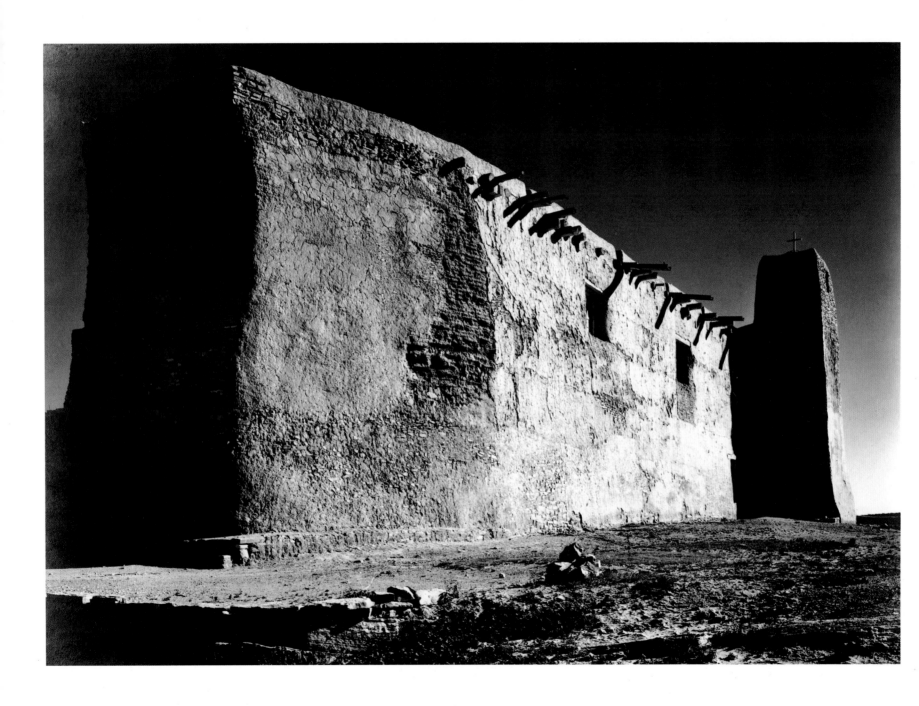

43. "Church, Acoma Pueblo"

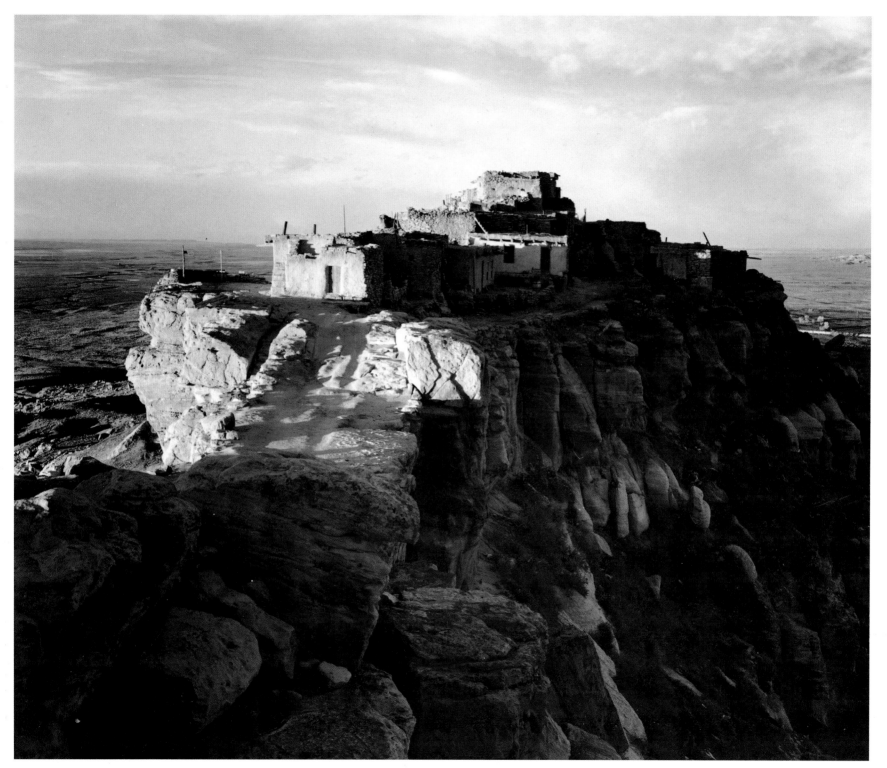

44. "Walpi, Arizona, 1941"

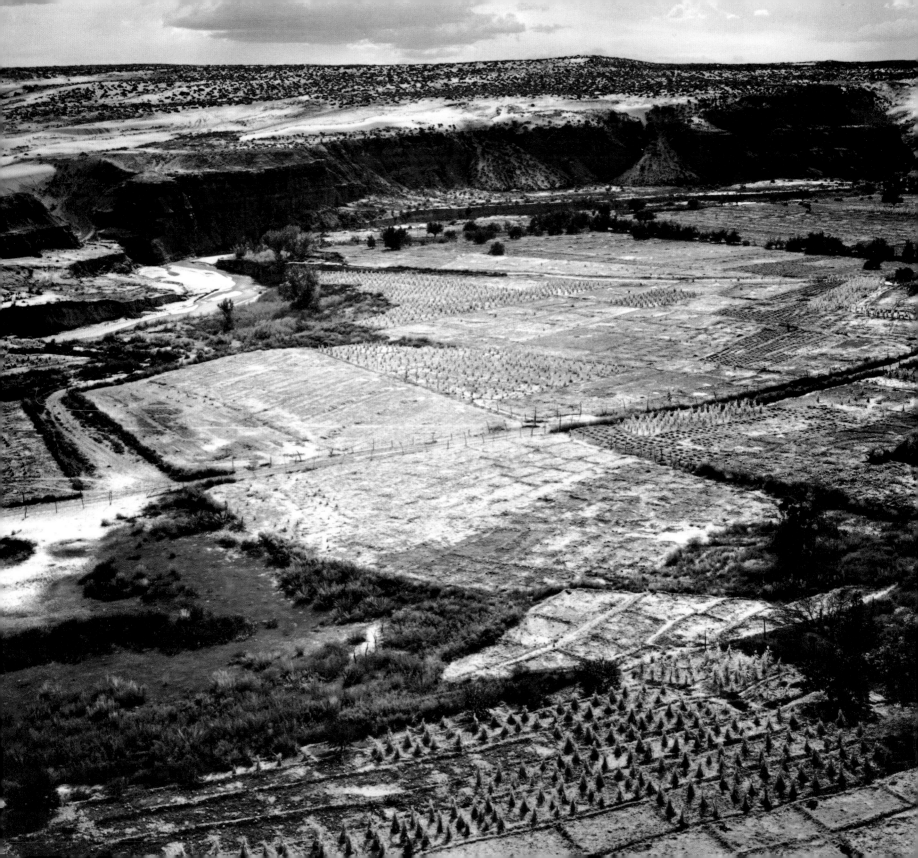

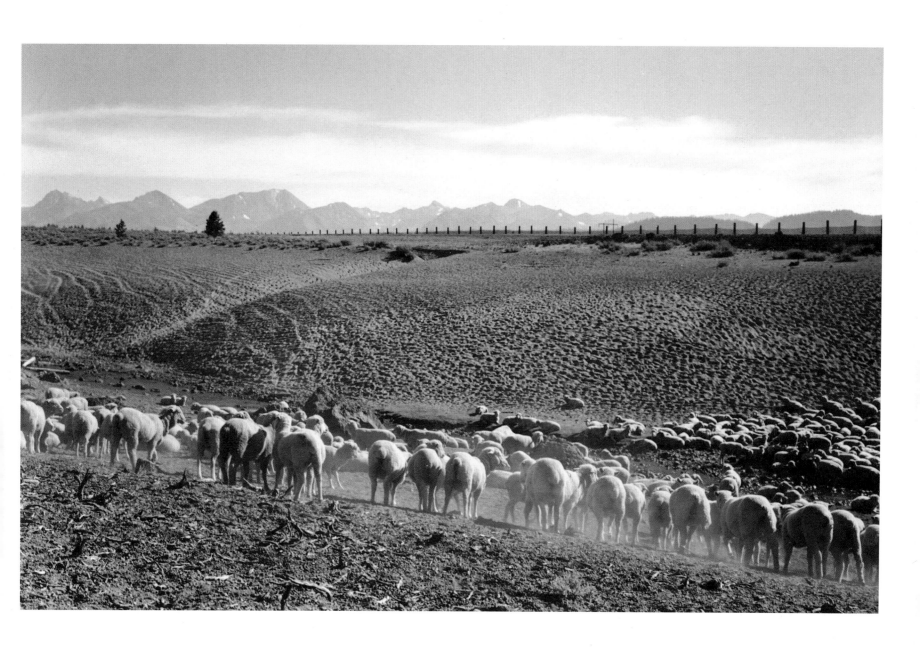

OPPOSITE: 45. "Corn Field, Indian Farm near Tuba City, Arizona, in rain, 1941"

ABOVE: 46. "Flock in Owens Valley, 1941"

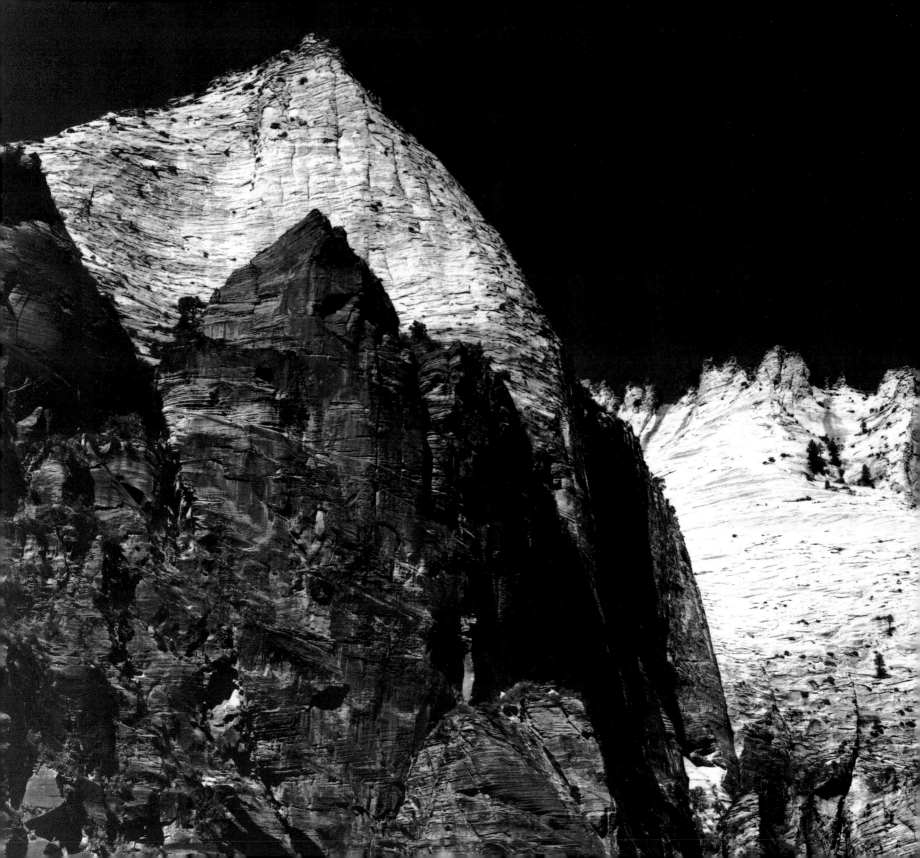

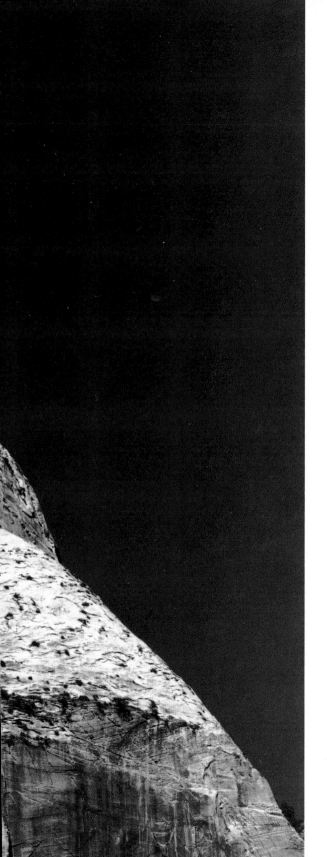

ZION NATIONAL PARK
Utah

SAGUARO
NATIONAL MONUMENT
Arizona

DEATH VALLEY
NATIONAL MONUMENT
California

47. "Zion National Park, 1941"

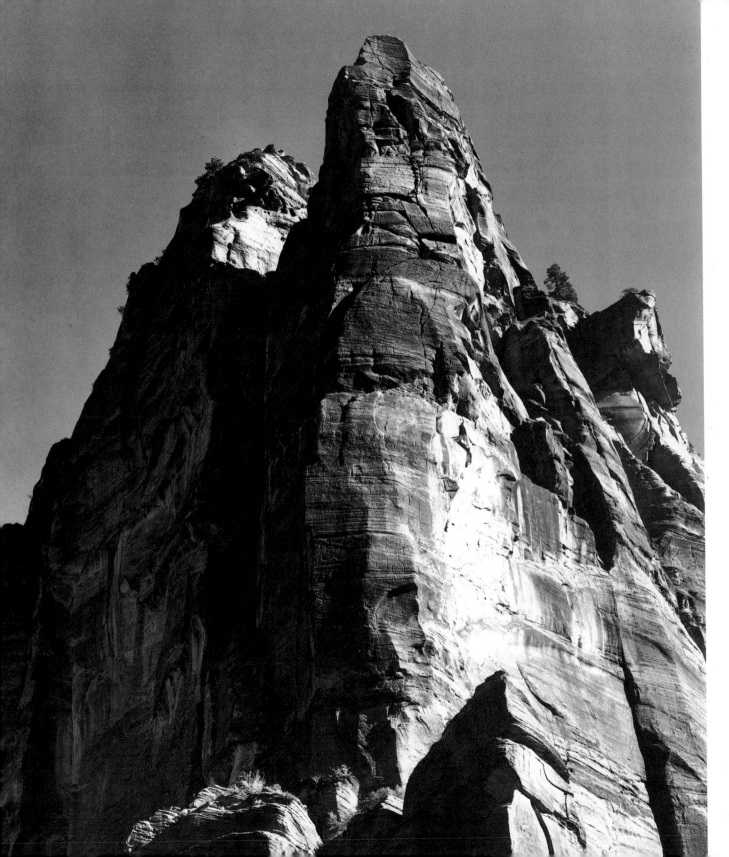

48. "In Zion National Park"

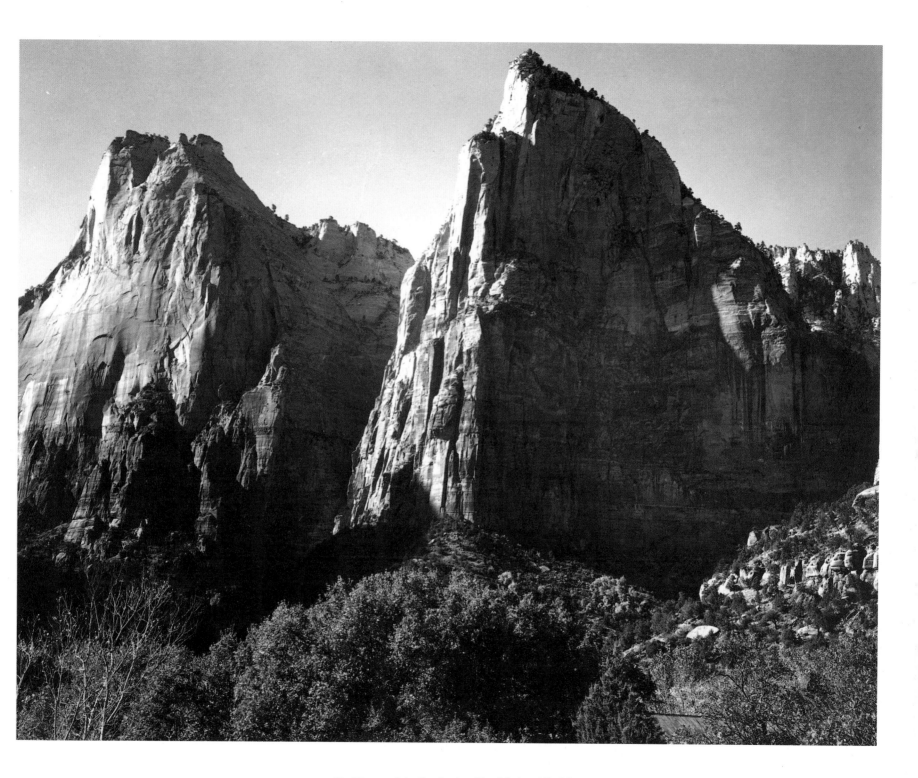

49. "Court of the Patriarchs, Zion National Park"

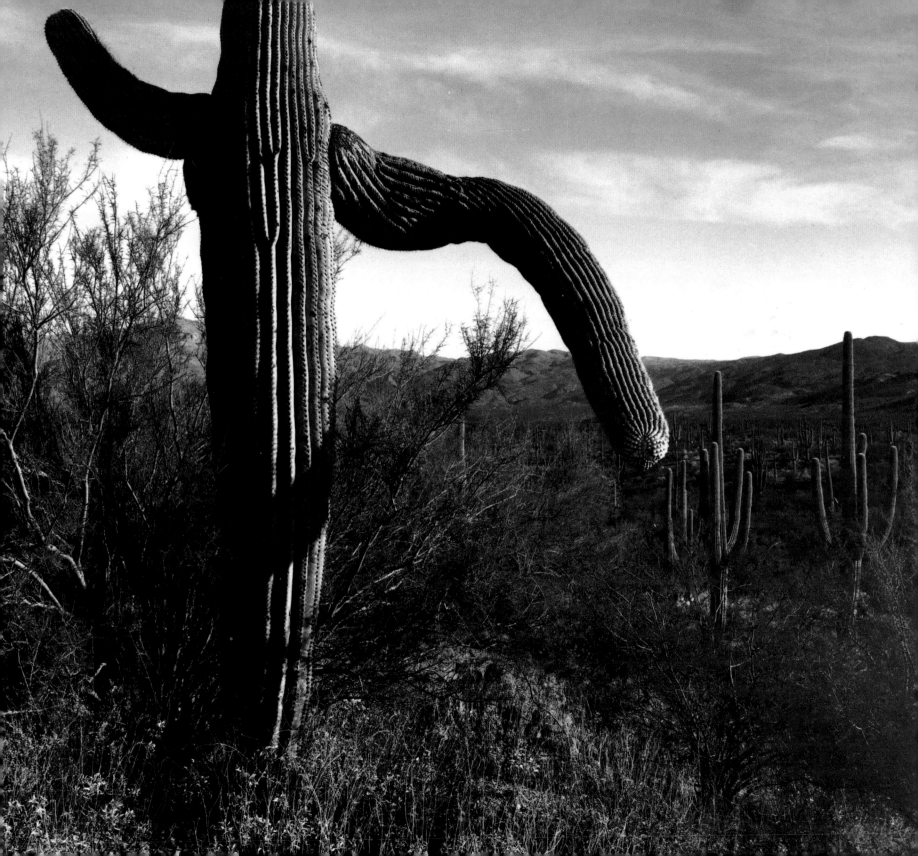

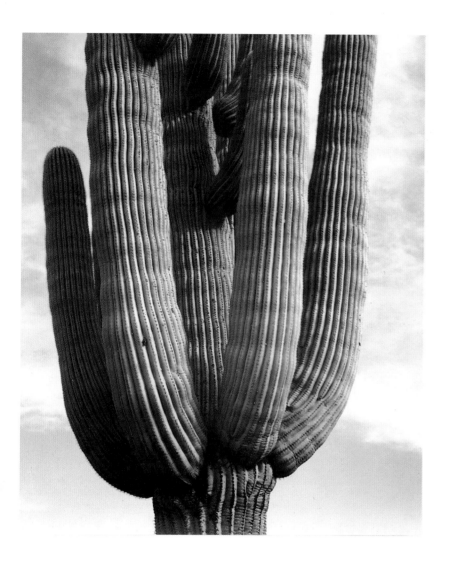
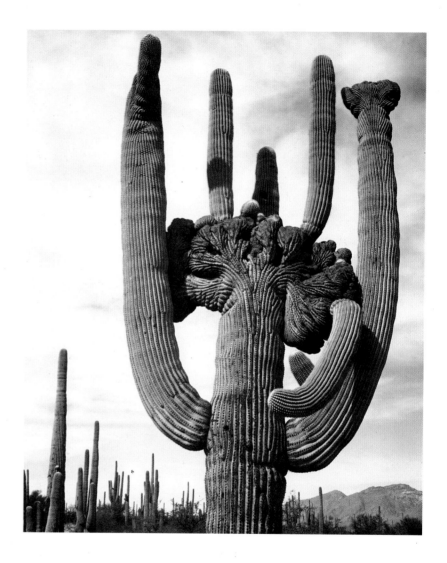

OPPOSITE: 50. "Saguaro National Monument"
ABOVE LEFT: 51. "Saguaros"
ABOVE RIGHT: 52. "Saguaros, Saguaro National Monument"

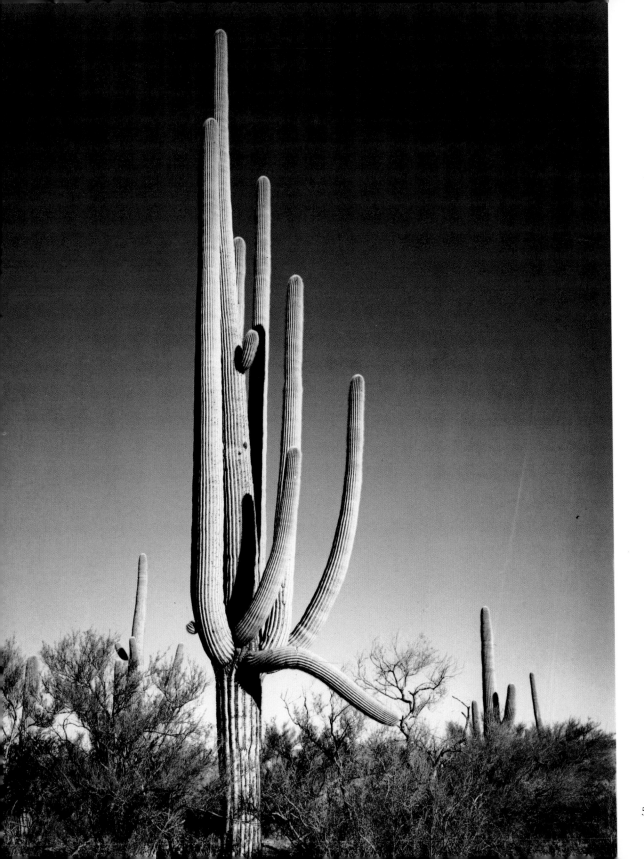

53. "In Saguaro National Monument"

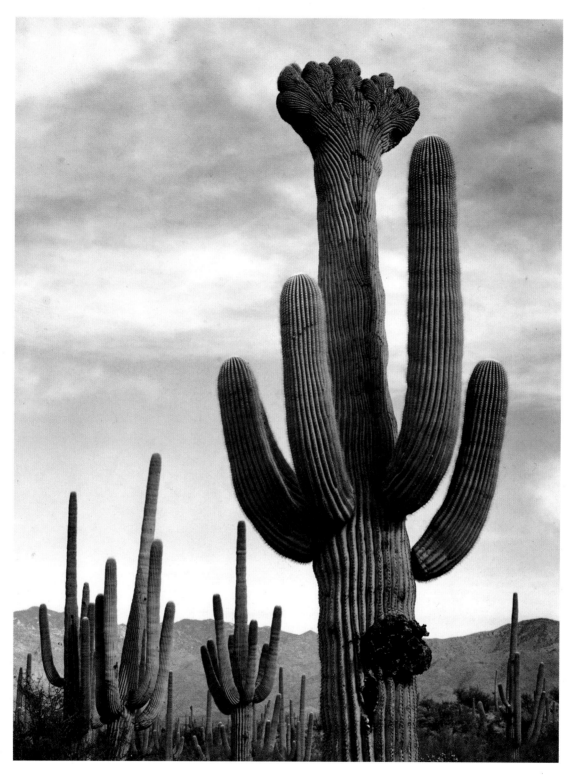

54. "Saguaros, Saguaro National Monument"

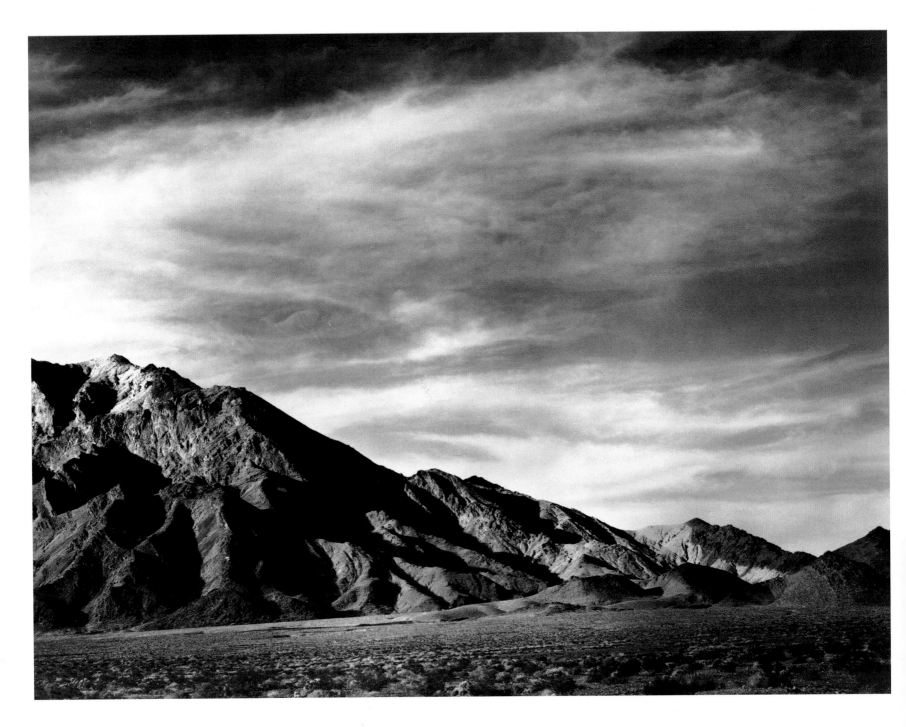

ABOVE: 55. "Near Death Valley"

OPPOSITE: 56. "Near Death Valley National Monument"

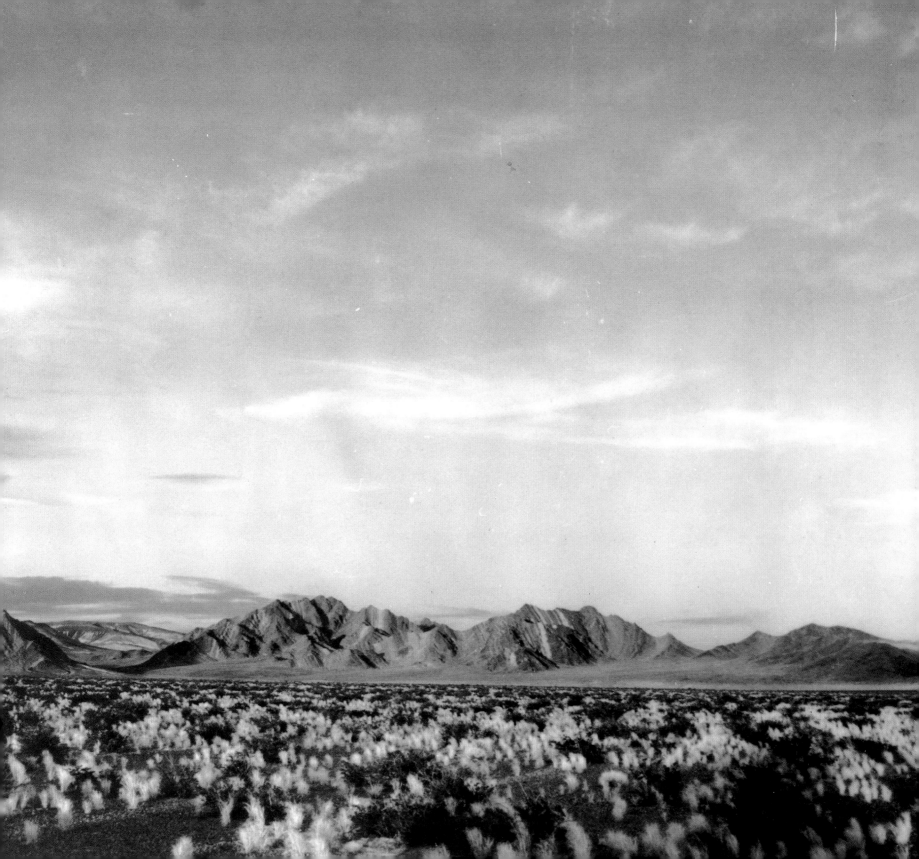

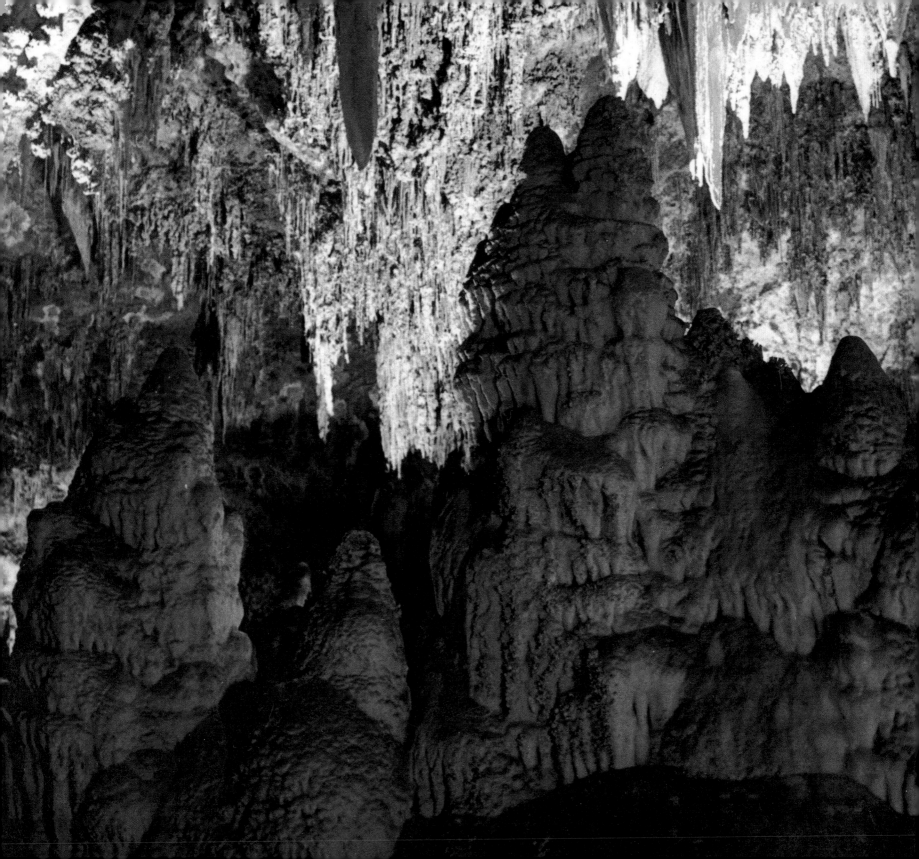

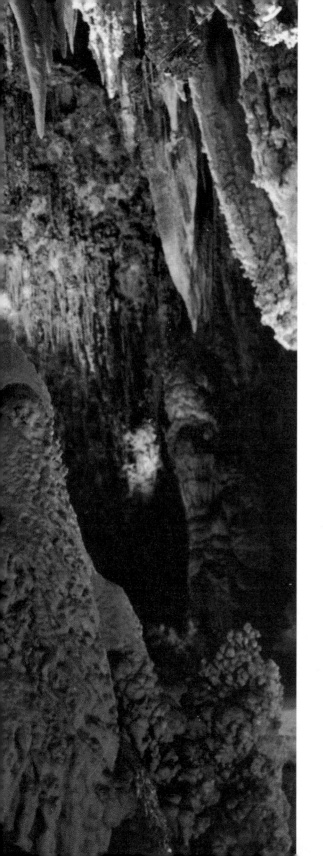

CARLSBAD CAVERNS NATIONAL PARK

New Mexico

57. "Formations along the wall of the Big Room,
near Crystal Spring Dome"

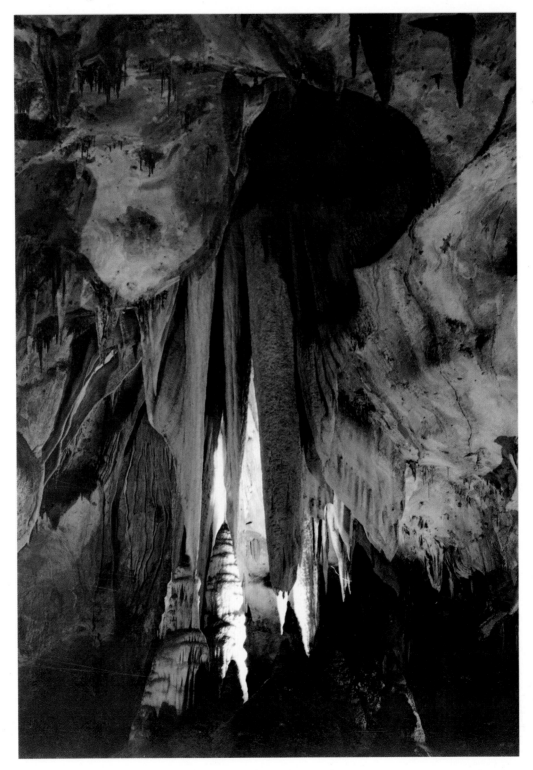

58. "Onyx drapes in the Papoose Room"

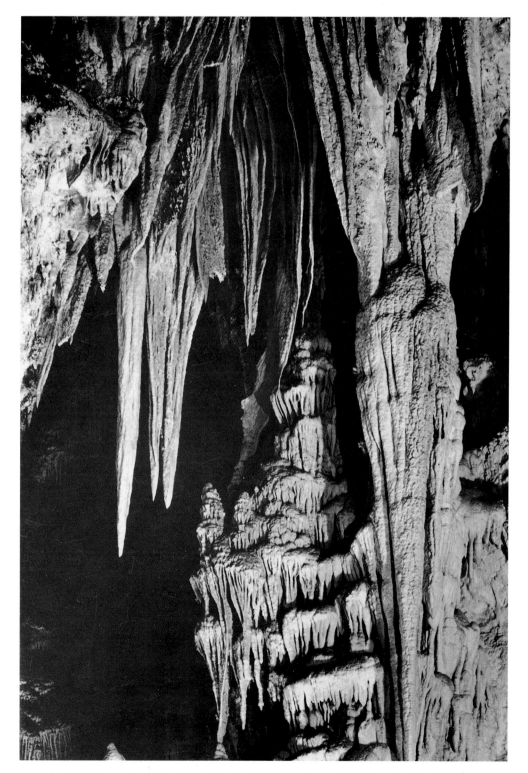

59. "Formations along the trail in the Big Room, beyond the Temple of the Sun"

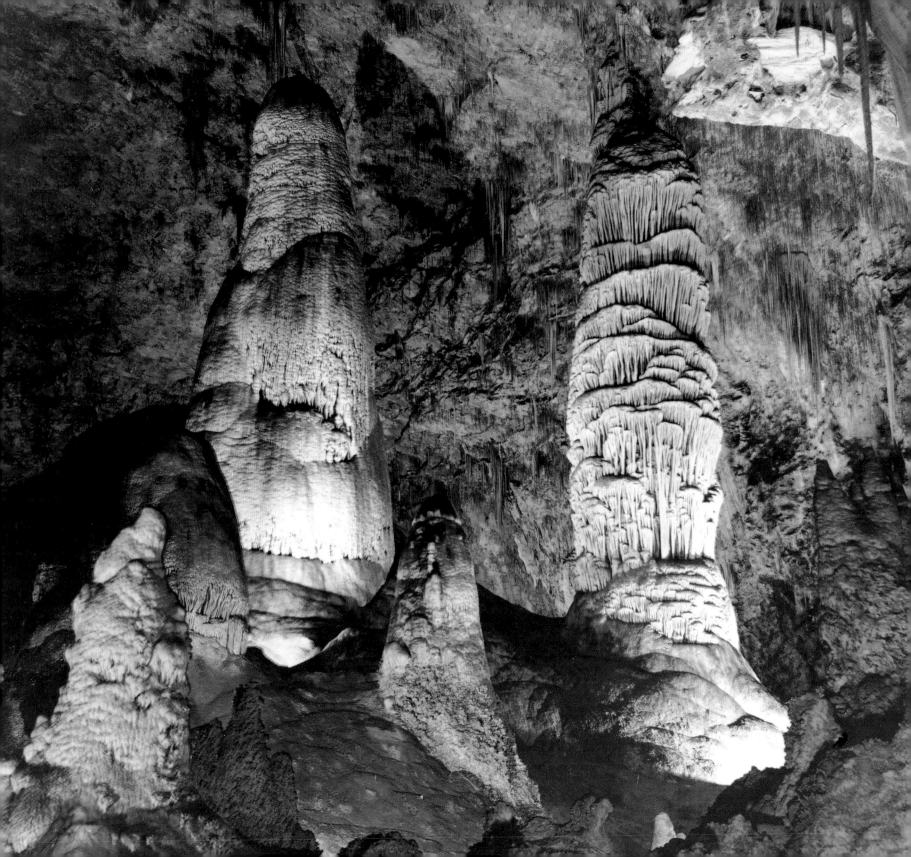

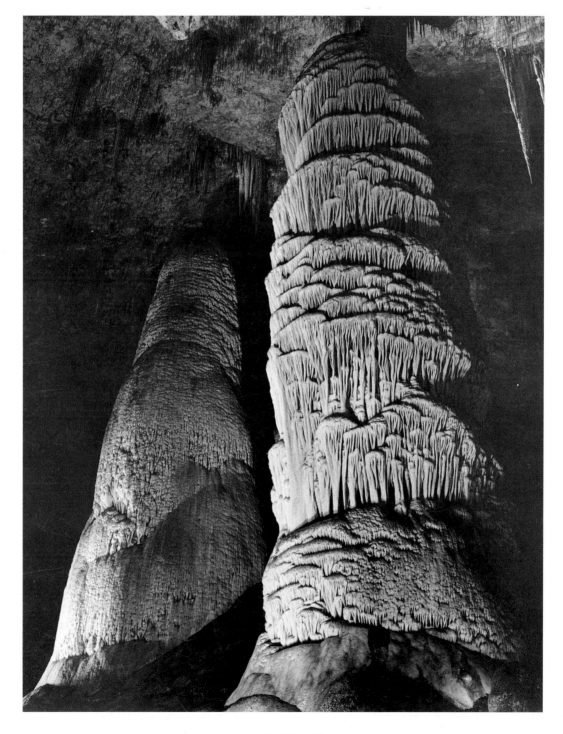

OPPOSITE: 60. "Giant Domes"

ABOVE: 61. "The Giant Dome, largest stalagmite thus far discovered. It is sixteen feet in diameter and estimated to be sixty million years old. Hall of Giants, Big Room."

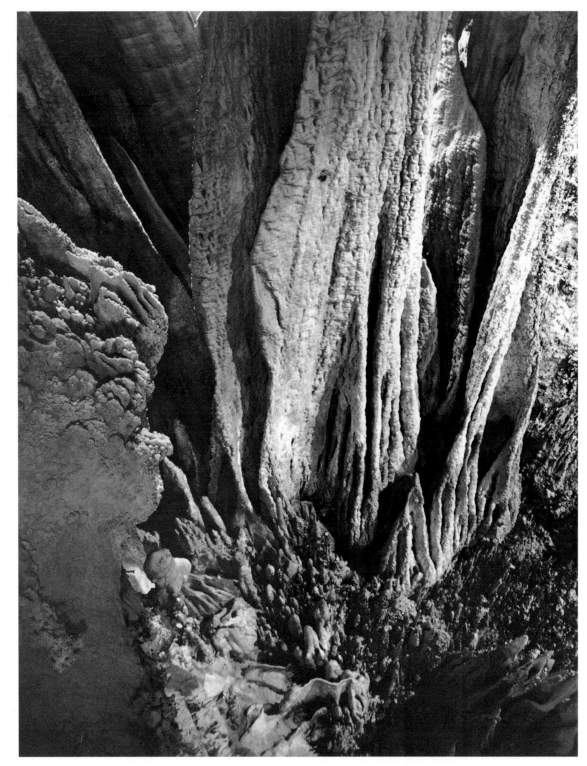

62. "Formations in the Big Room near the Temple of the Sun, detail"

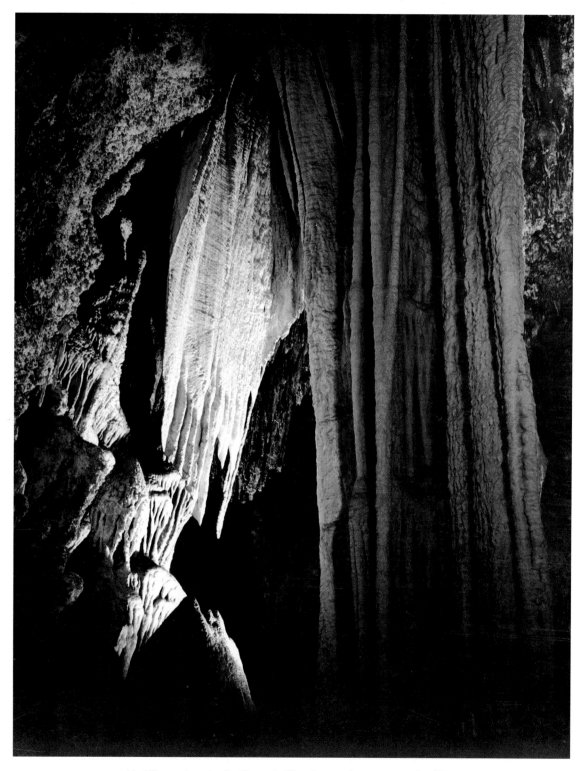

63. "Formations in the Queen's Chamber, at the entrance, detail"

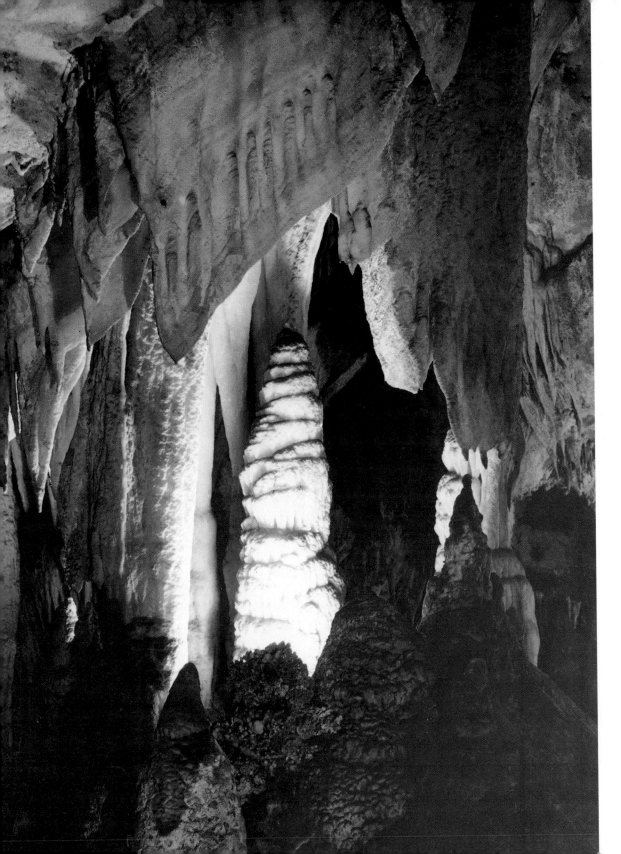

64. "Formations, stalagmites, in the Queen's Chamber"

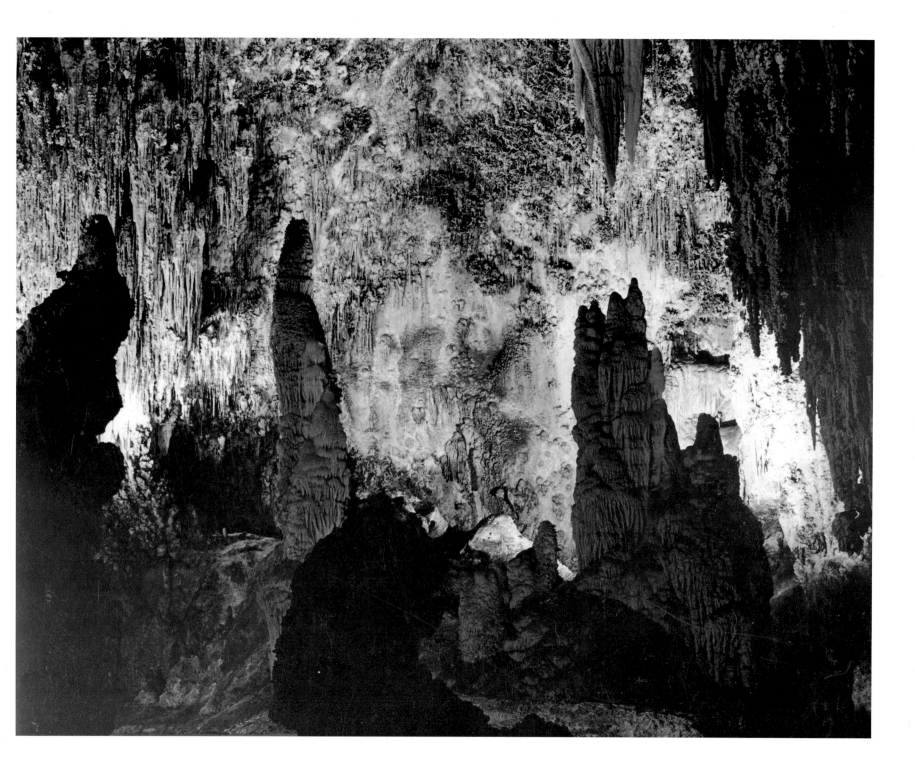

65. "In the Queen's Chamber"

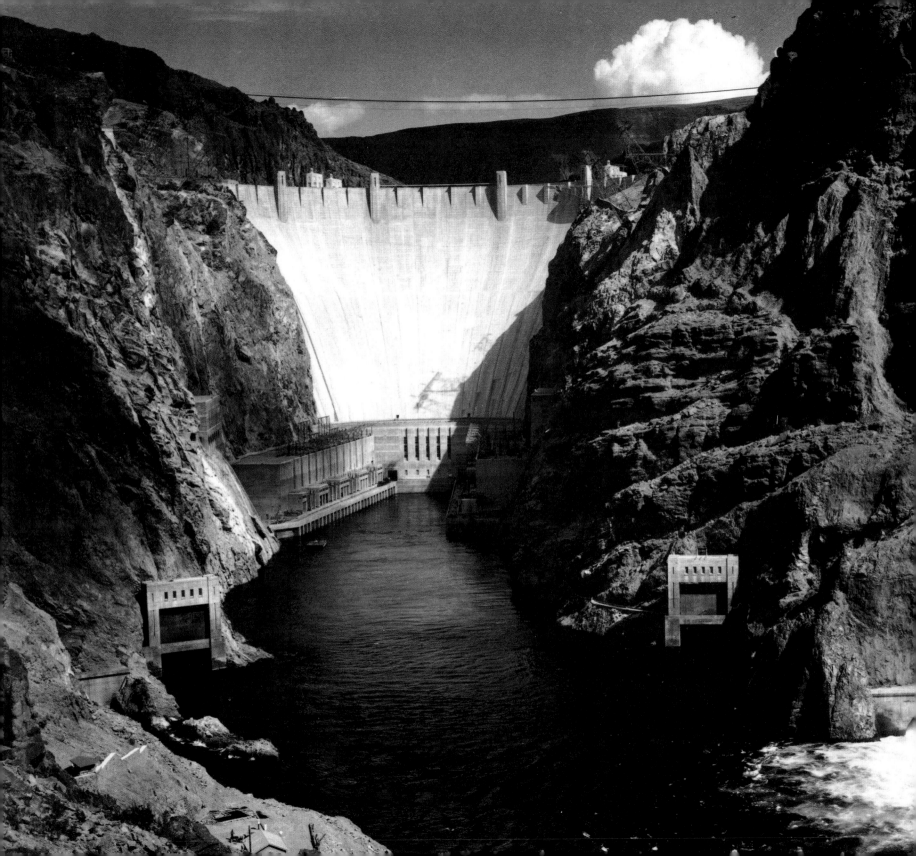

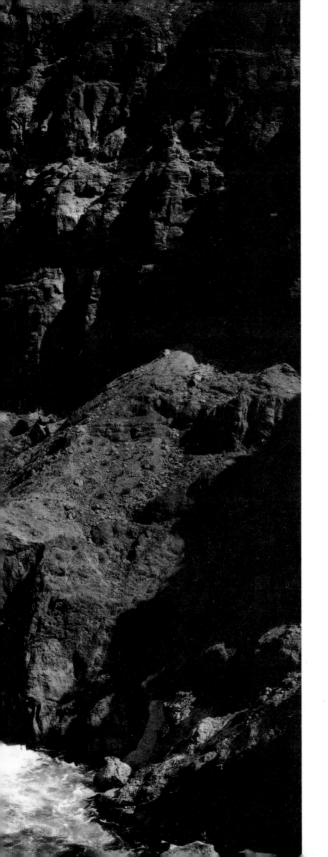

BOULDER DAM

Colorado

66. "Boulder Dam, 1941"

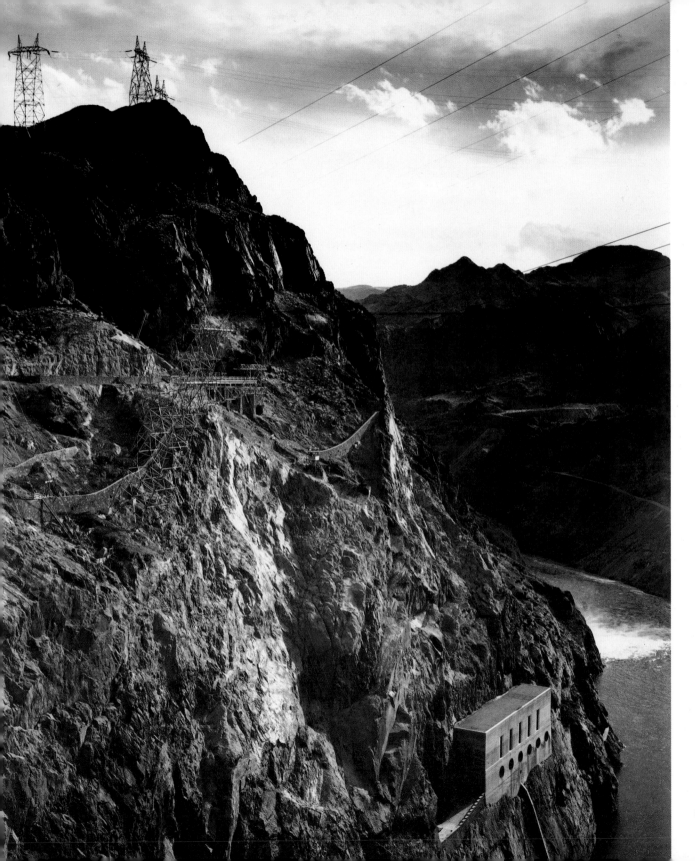

67. "Boulder Dam, 1941"

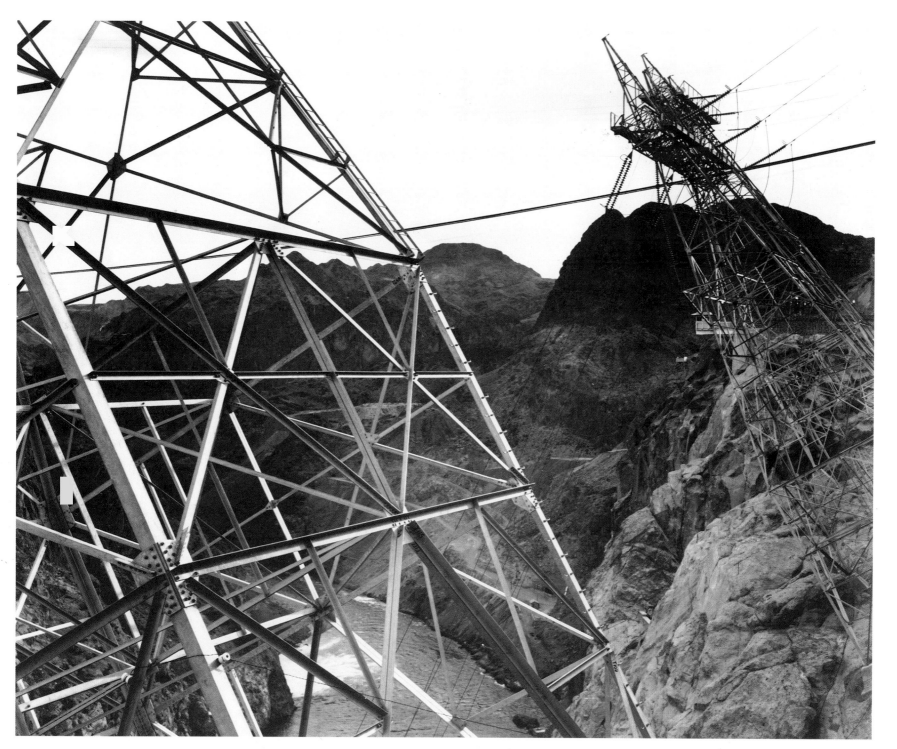

68. "Boulder Dam, 1941"

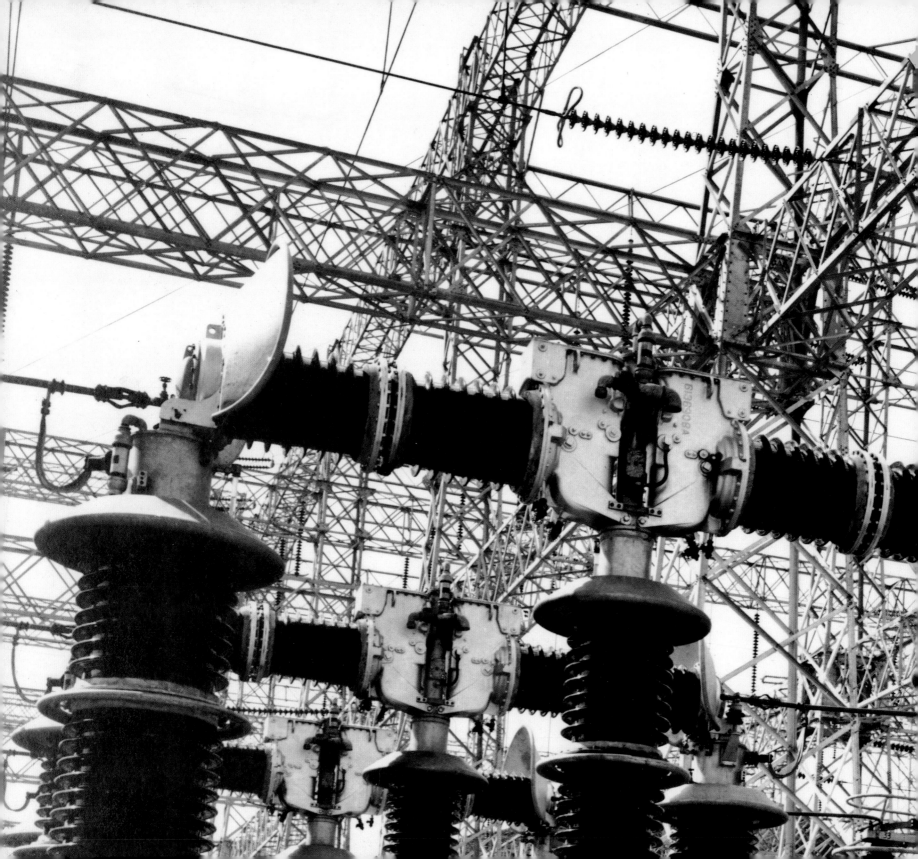

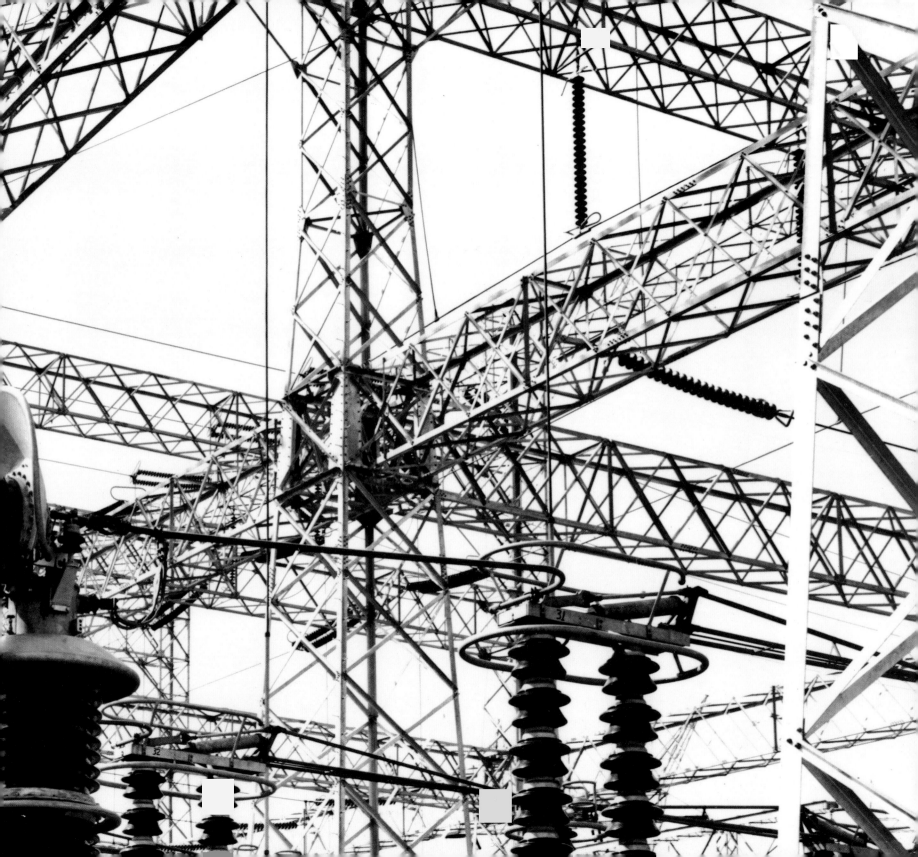

PRECEDING PAGES: 69. "Boulder Dam Power Unit, 1941" (detail)

ABOVE: 70. "Boulder Dam, 1941"

71. "Transmission lines in the Mojave Desert, 1941"

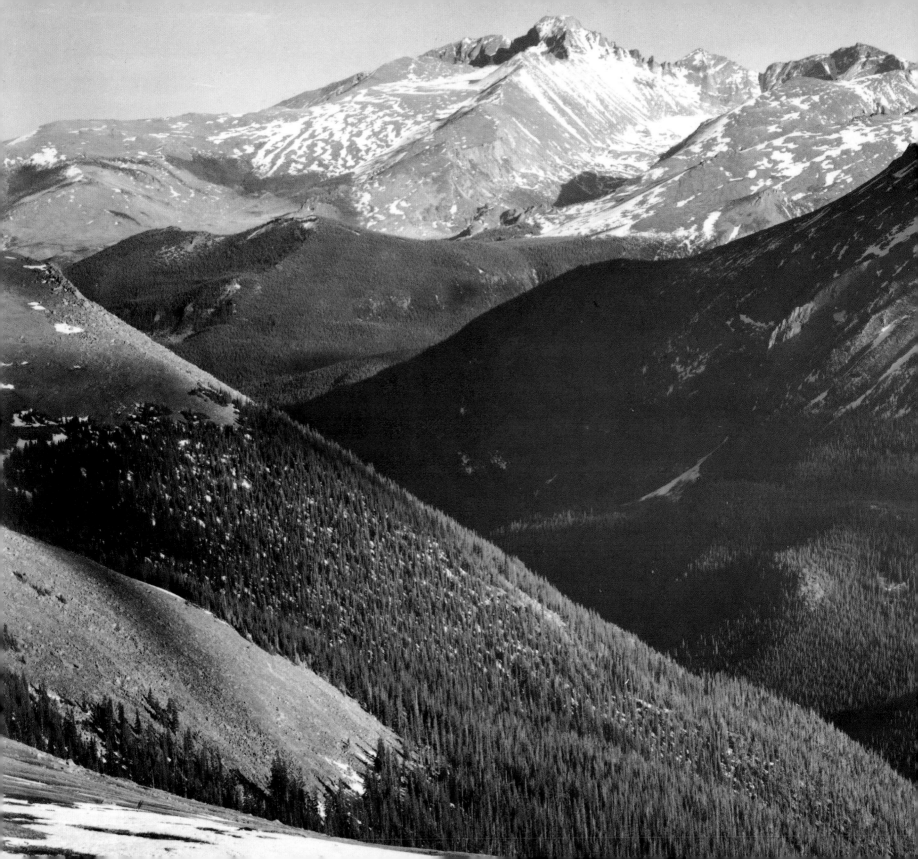

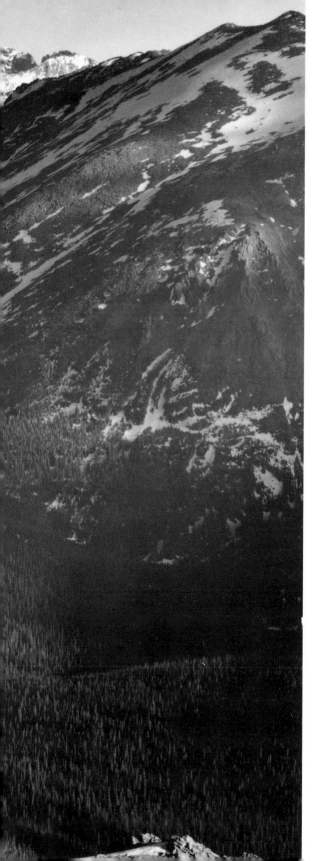

ROCKY MOUNTAIN NATIONAL PARK

Colorado

72. "Long's Peak, Rocky Mountain National Park"

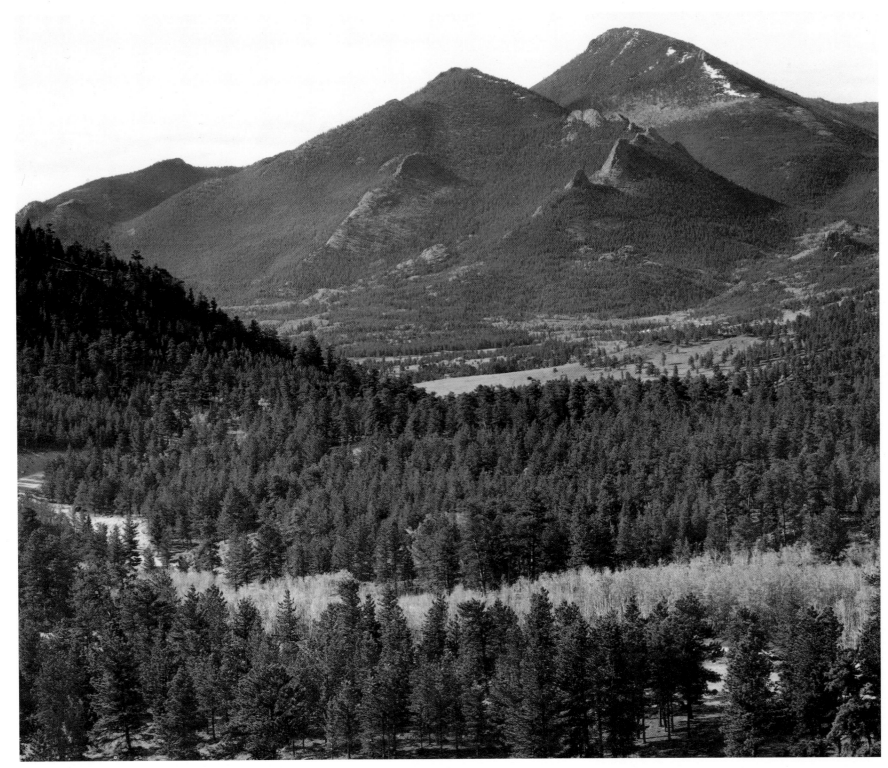

73. "In Rocky Mountain National Park"

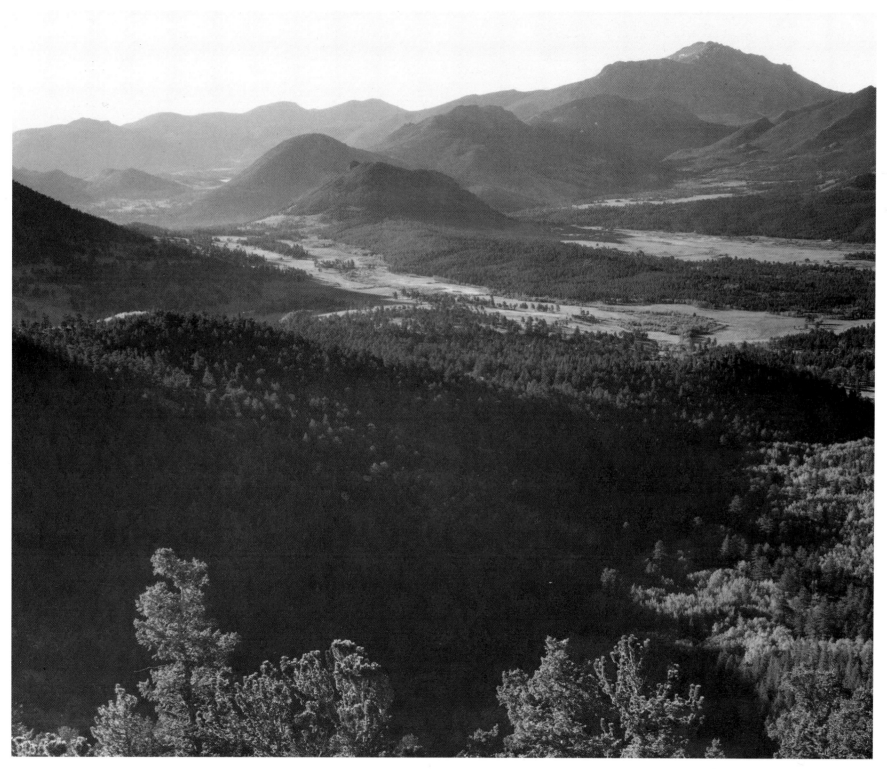

74. "In Rocky Mountain National Park"

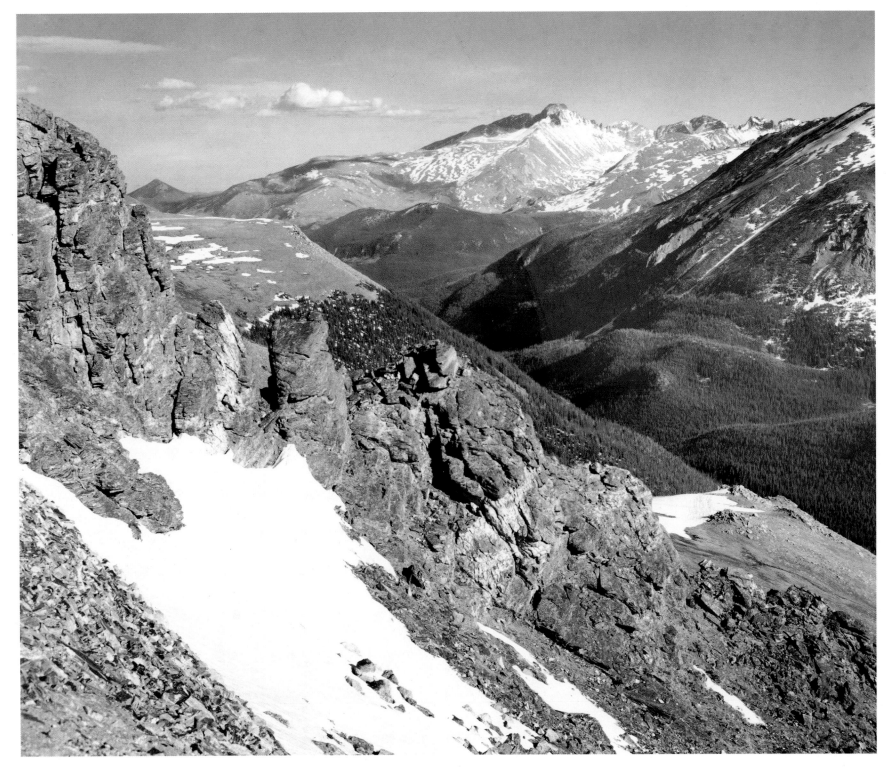

75. "Long's Peak, Rocky Mountain National Park"

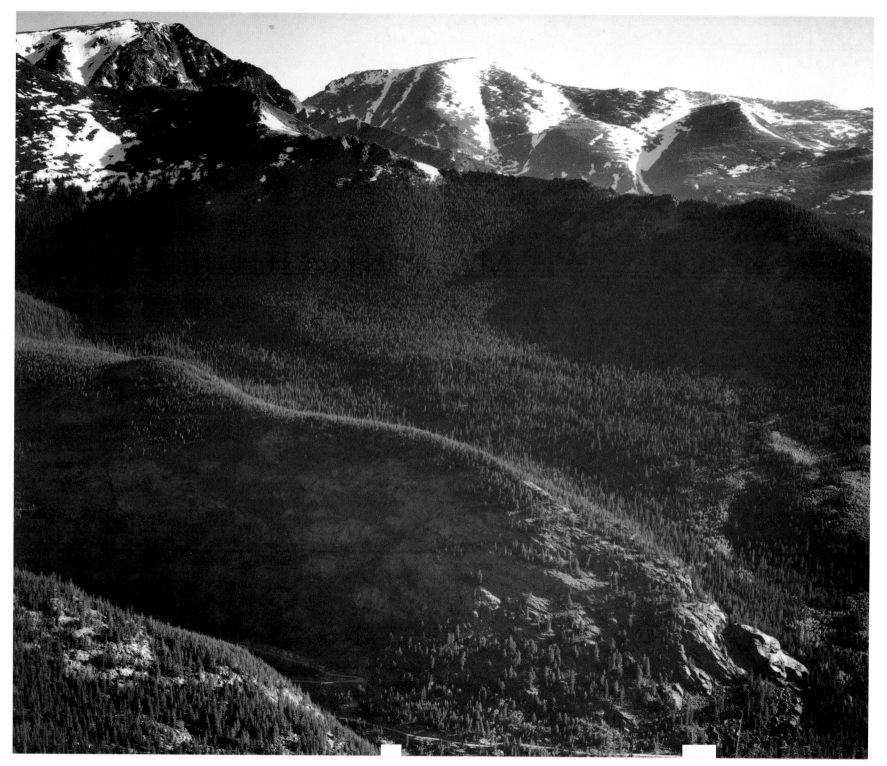

76. "In Rocky Mountain National Park"

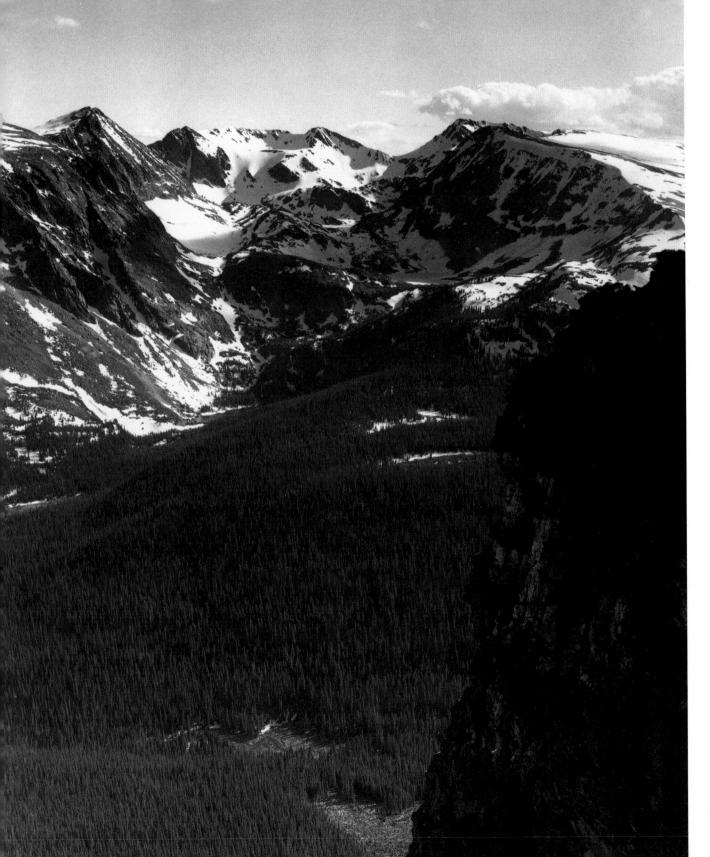

77. "In Rocky Mountain National Park"

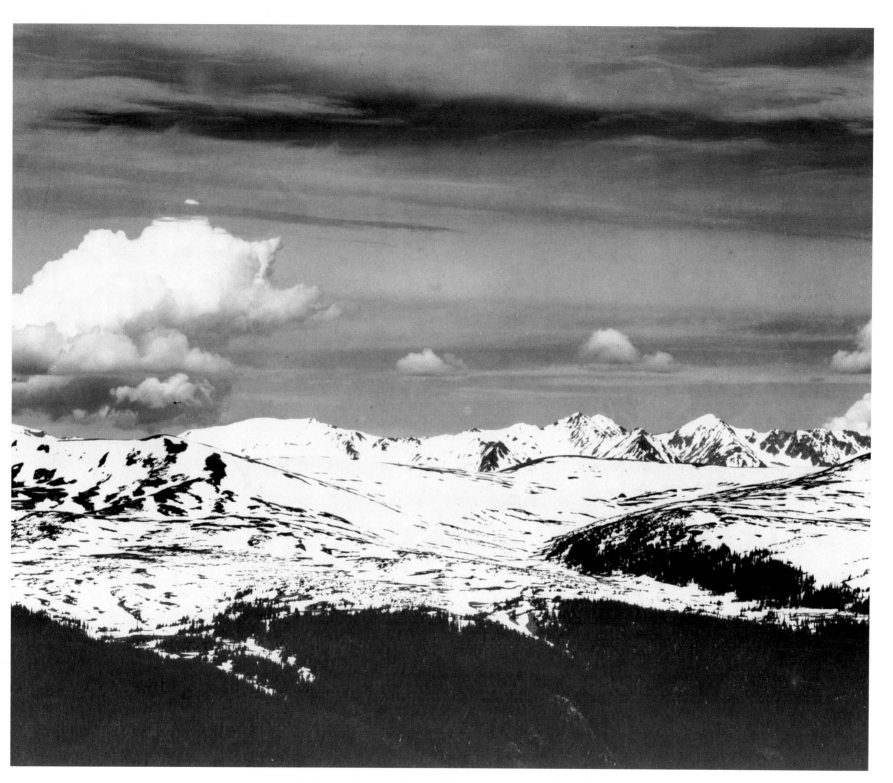

78. "Rocky Mountain National Park, Never Summer Range"

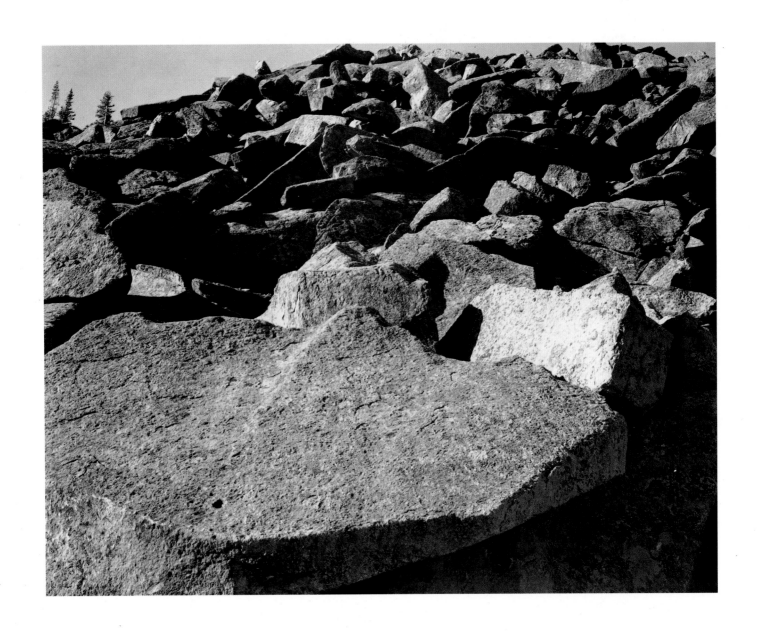

79. "Moraine, Rocky Mountain National Park"

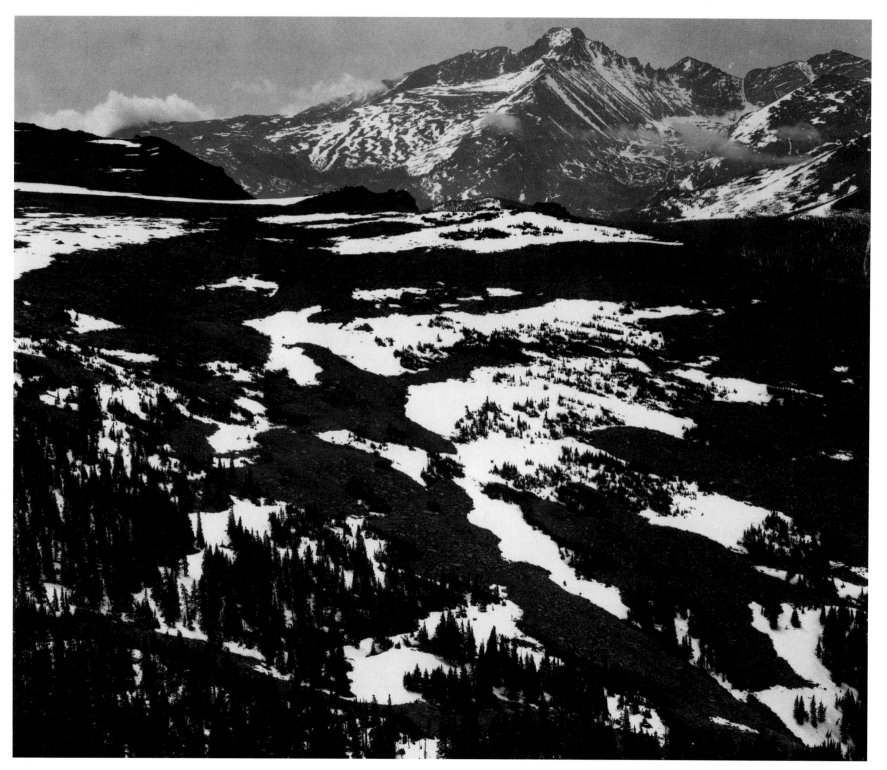

80. "Long's Peak, Rocky Mountain National Park"

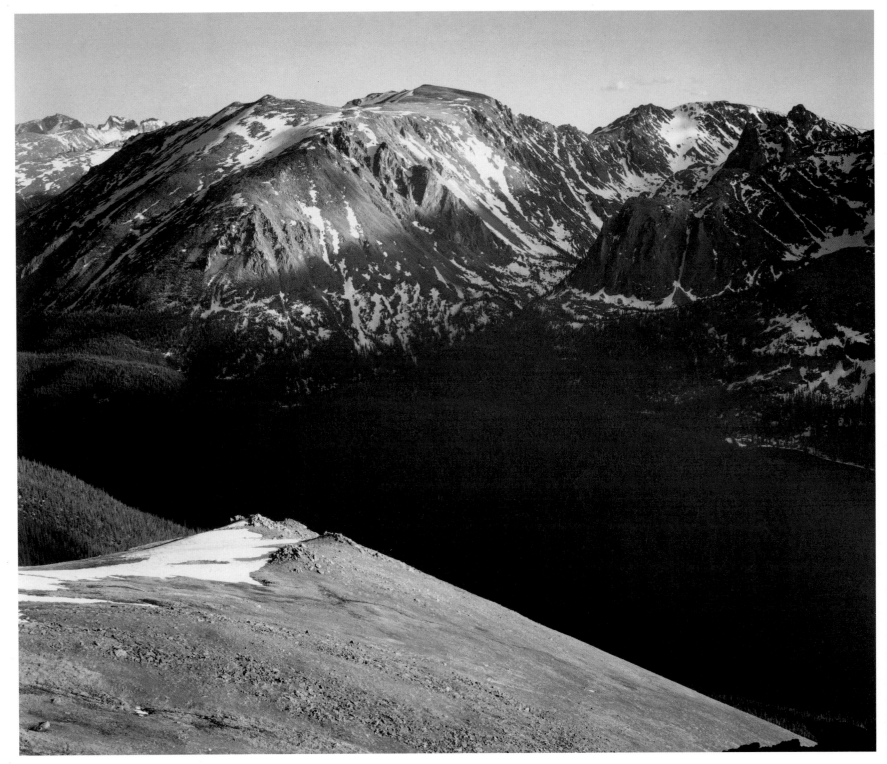

81. "In Rocky Mountain National Park"

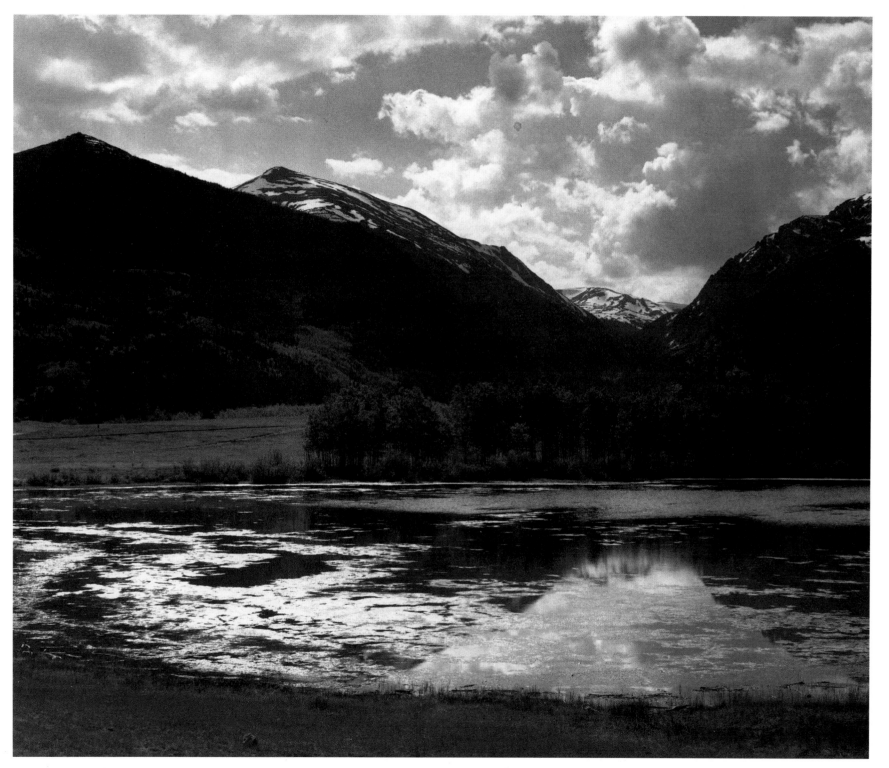

82. "In Rocky Mountain National Park"

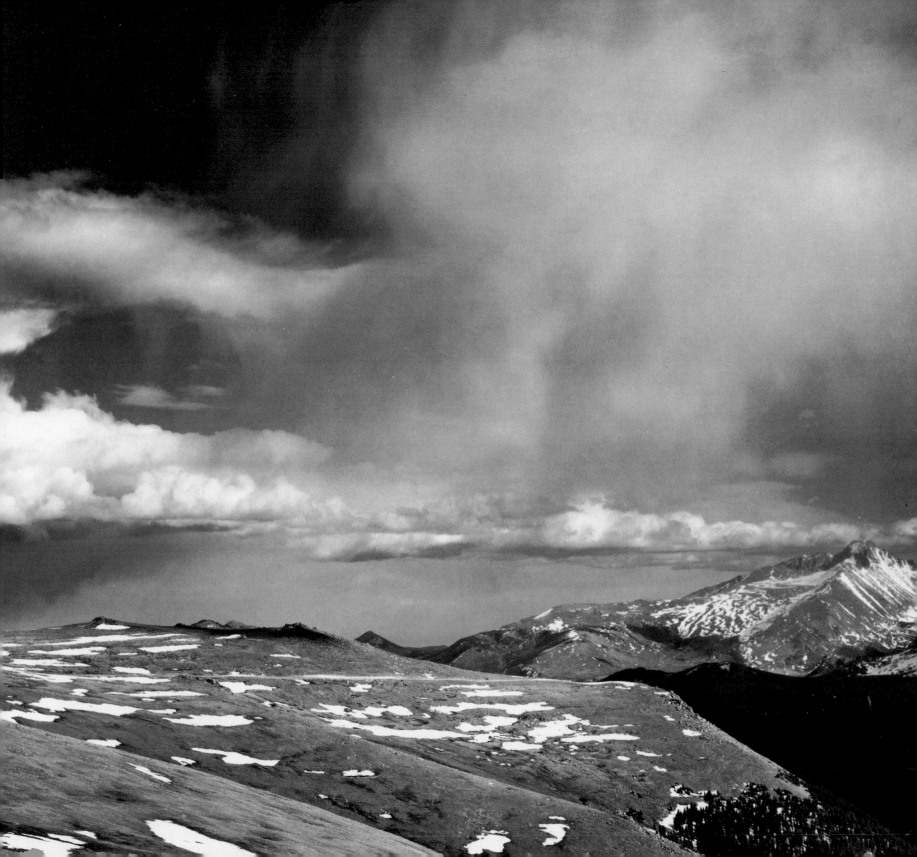

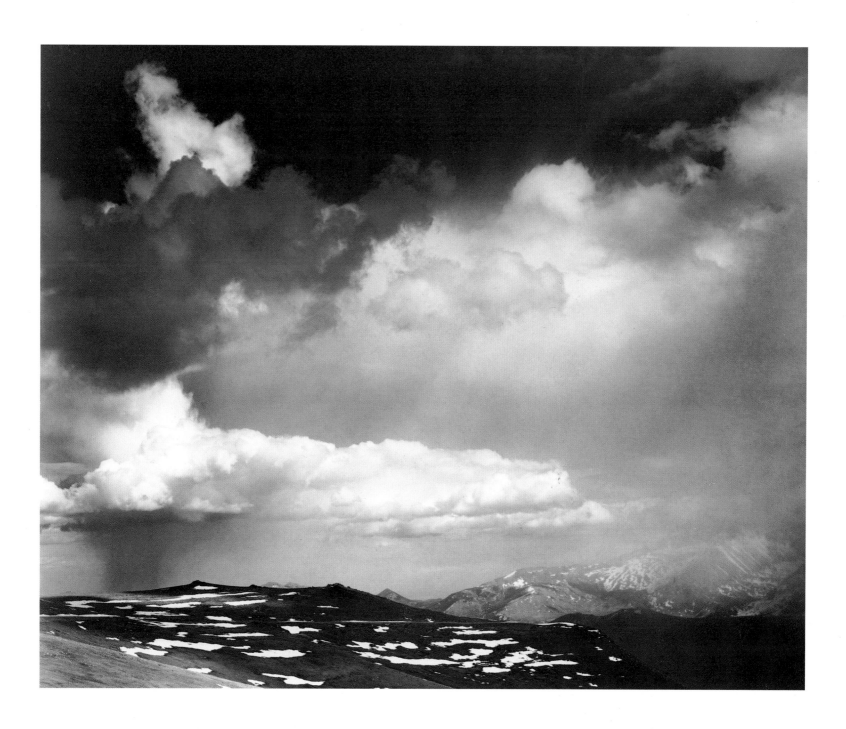

OPPOSITE: 83. "In Rocky Mountain National Park"

ABOVE: 84. "In Rocky Mountain National Park"

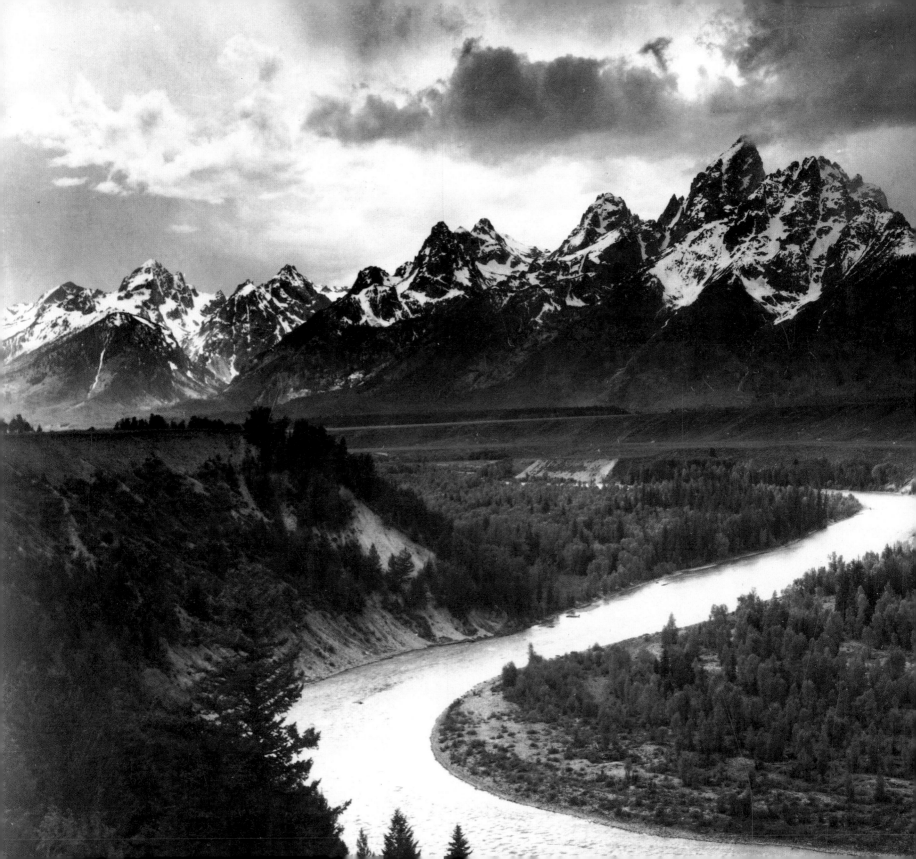

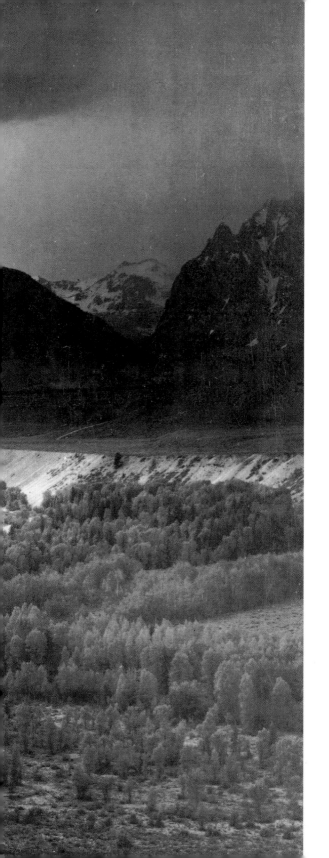

GRAND TETON
NATIONAL PARK

Wyoming

85. "The Tetons—Snake River"

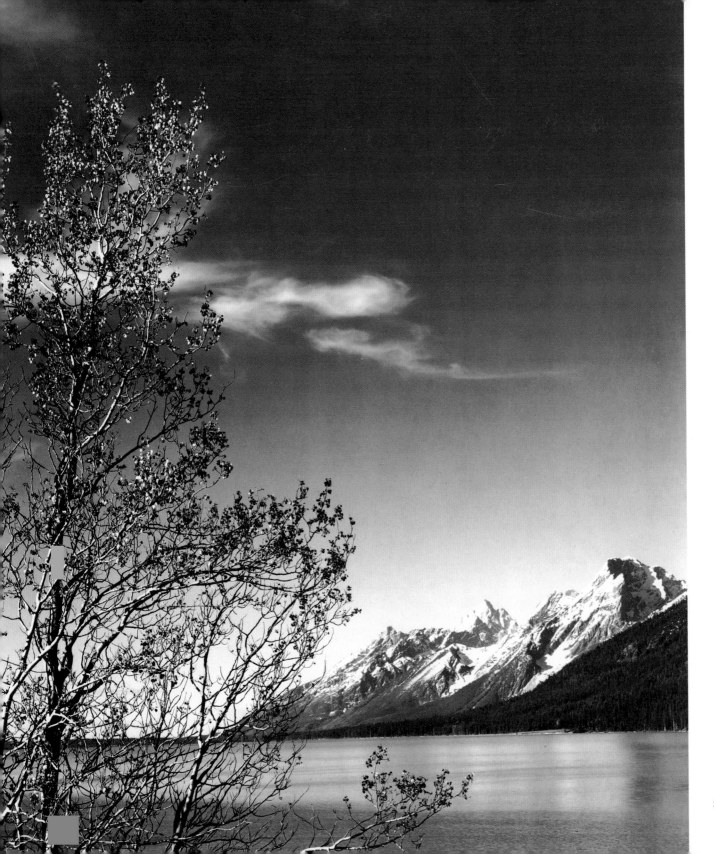

86. "Grand Teton"

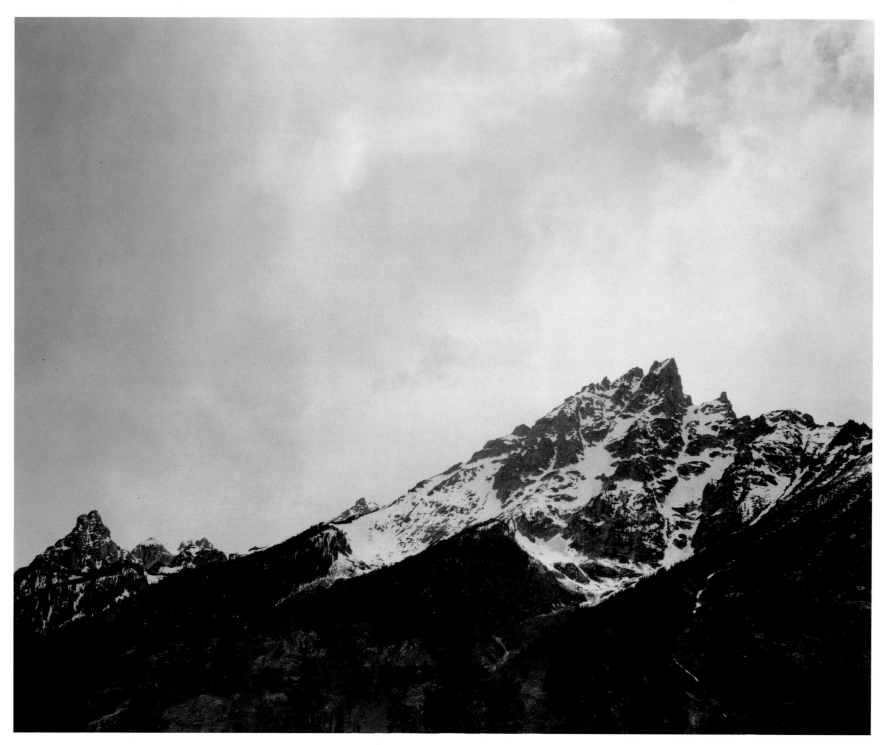

ABOVE: 87. "In Teton National Park"

OVERLEAF: 88. "Tetons from Signal Mountain" (detail)

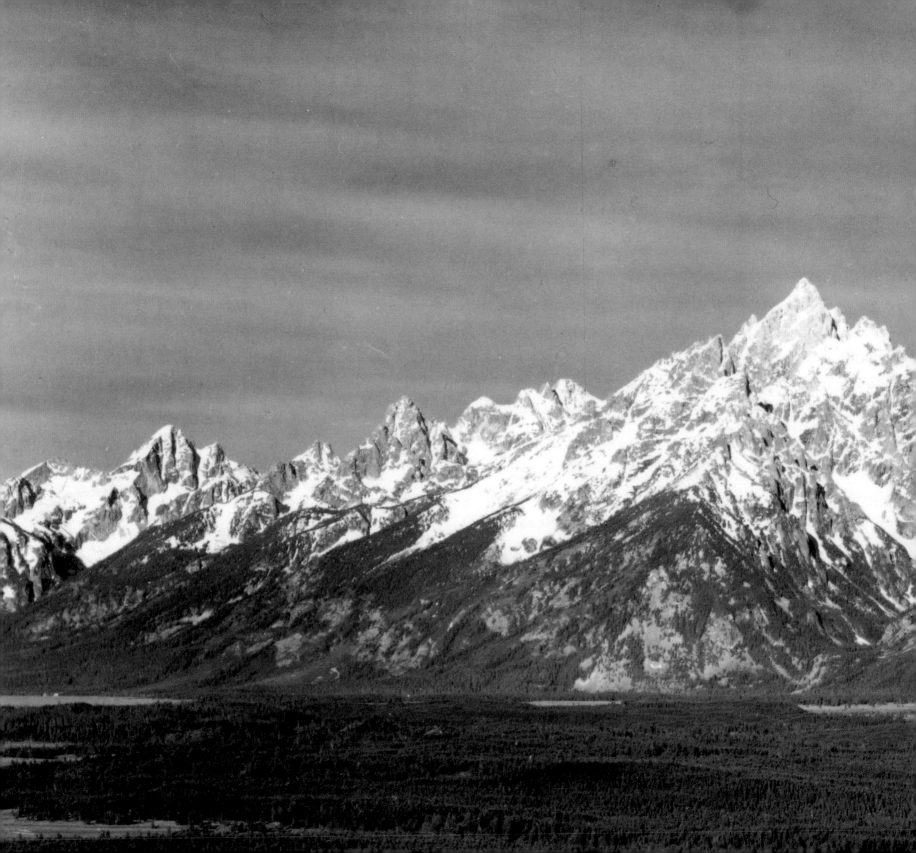

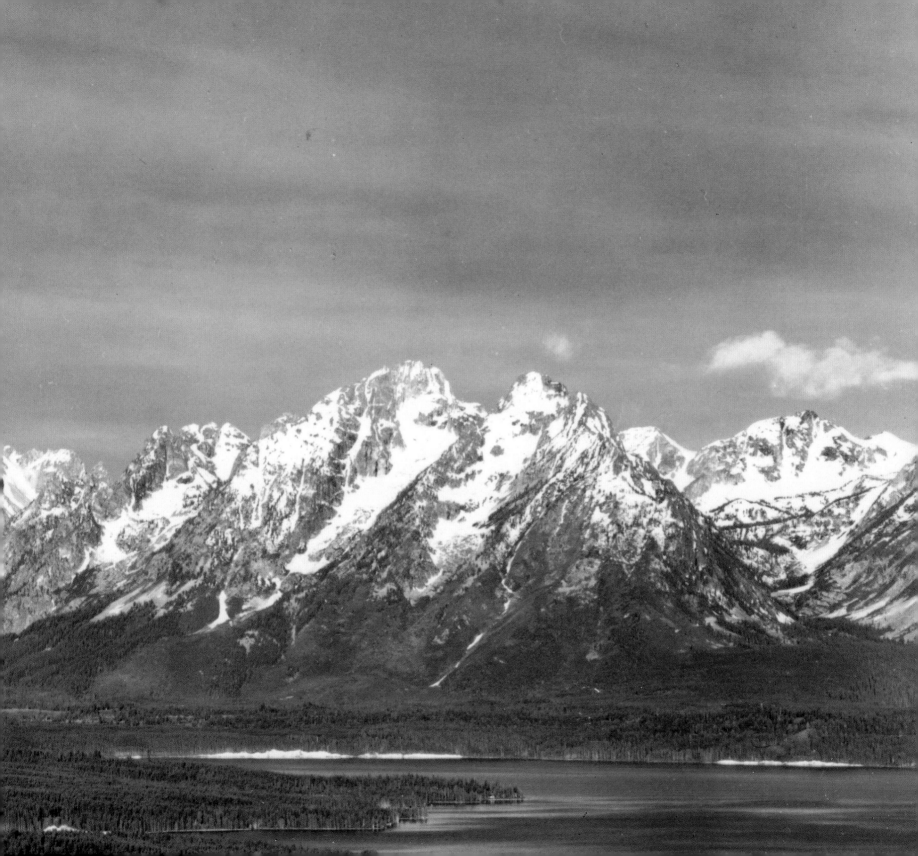

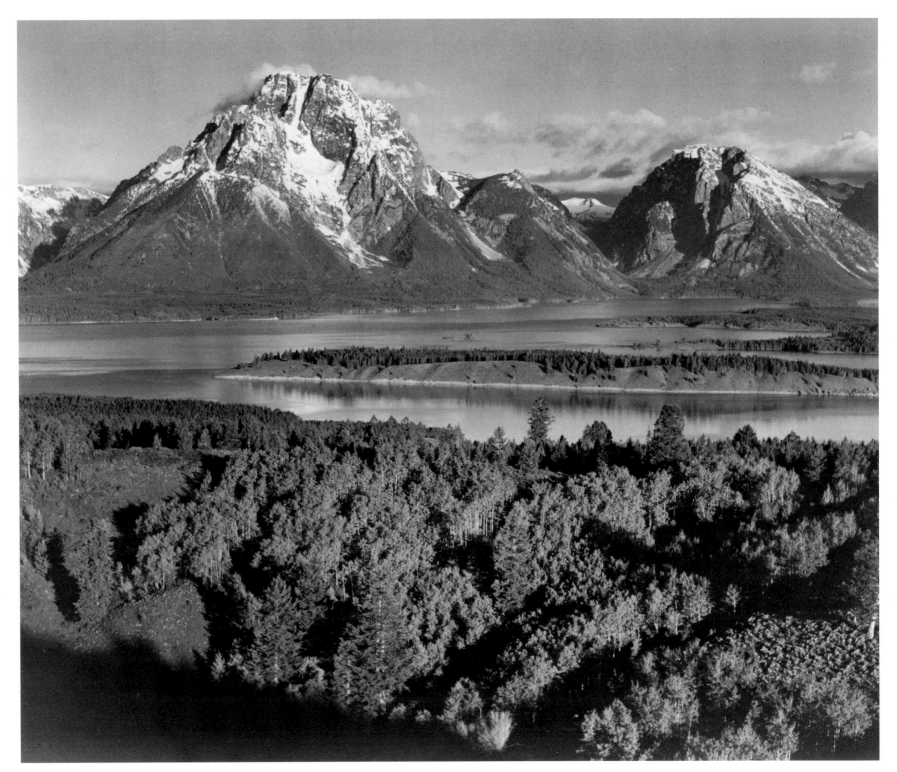

89. "Mt. Moran, Teton National Park"

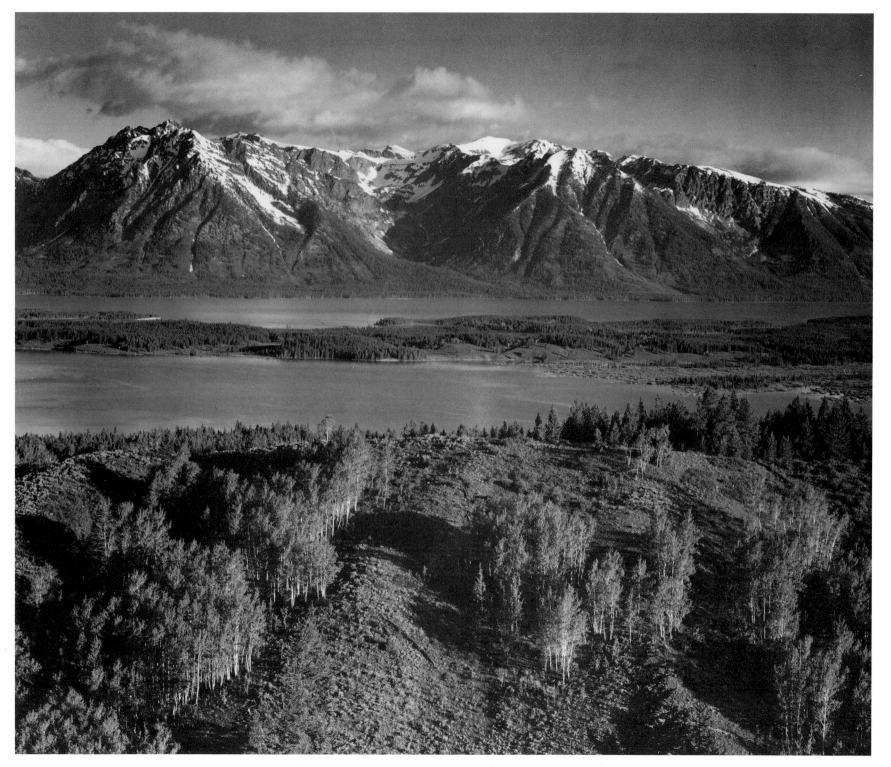

90. "Grand Teton"

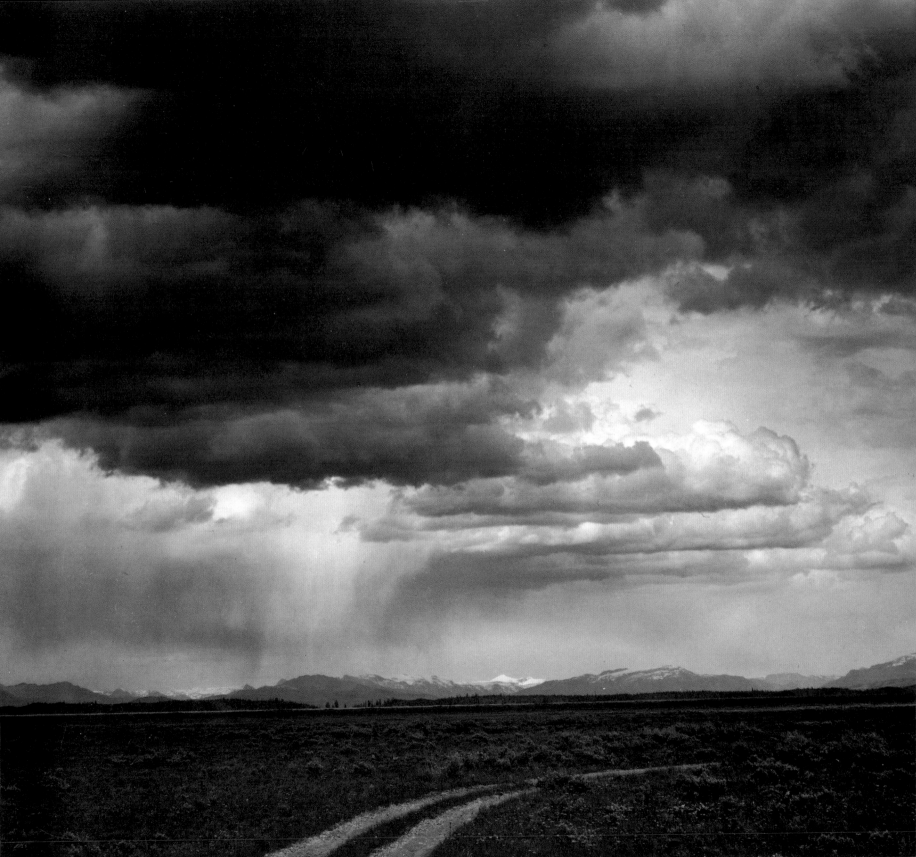

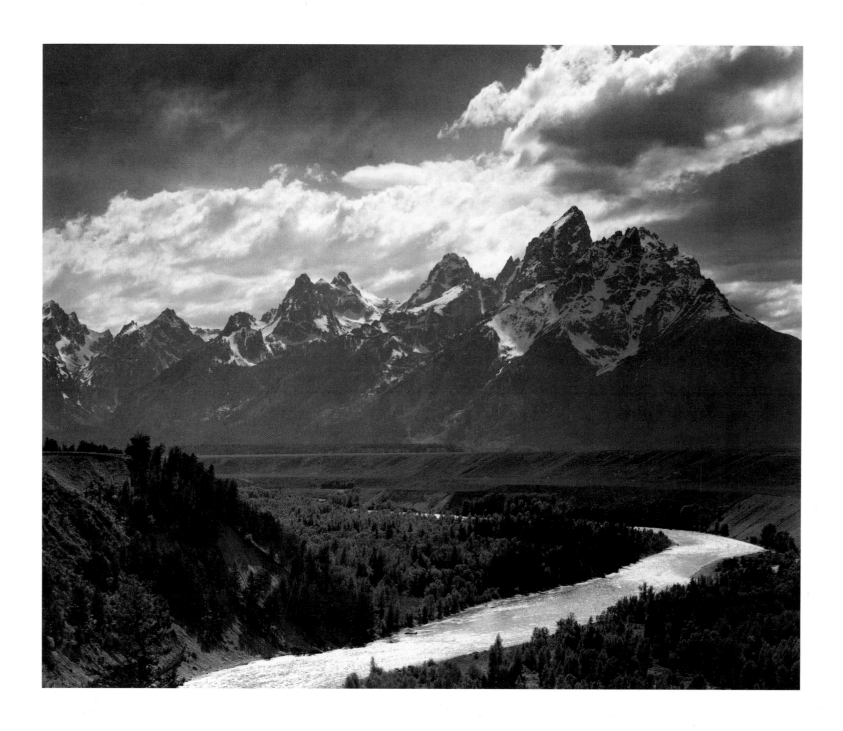

OPPOSITE: 91. "Near Teton National Park"

ABOVE: 92. "Grand Teton"

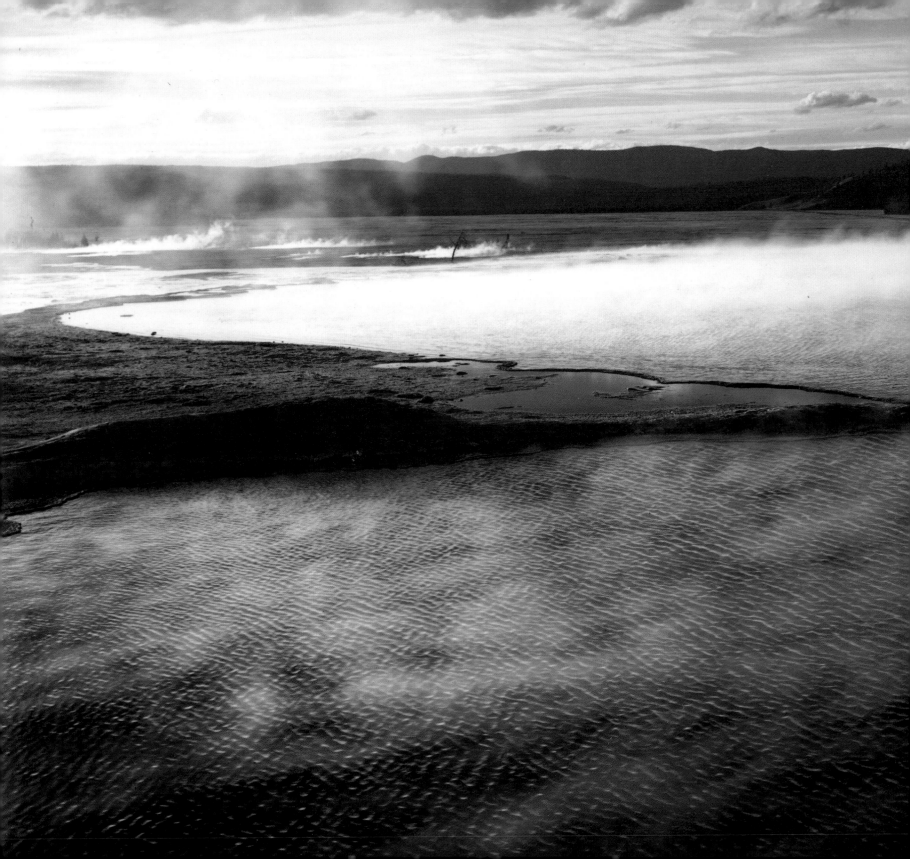

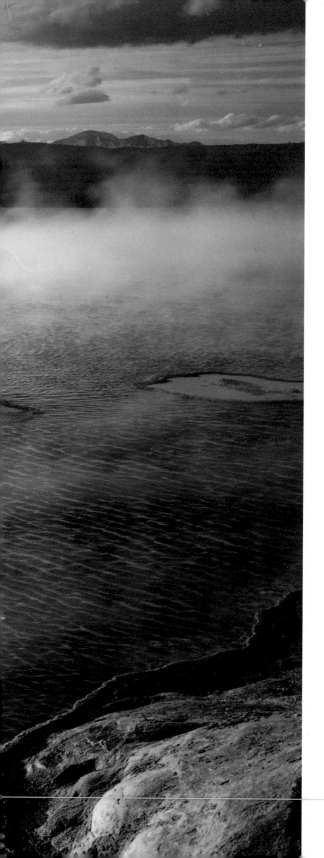

YELLOWSTONE NATIONAL PARK

Wyoming

93. "Fountain Geyser Pool, Yellowstone National Park"

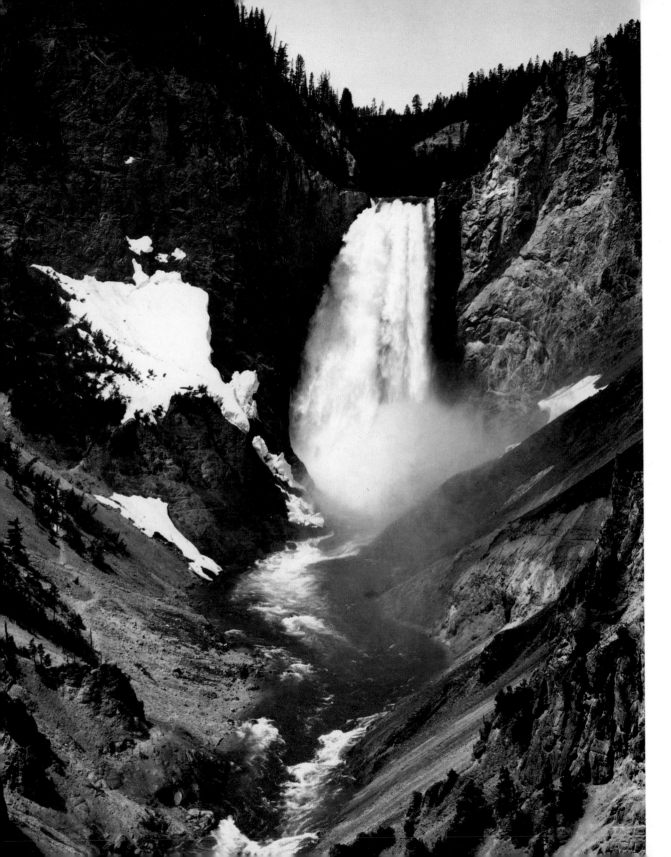

94. "Yellowstone Falls"

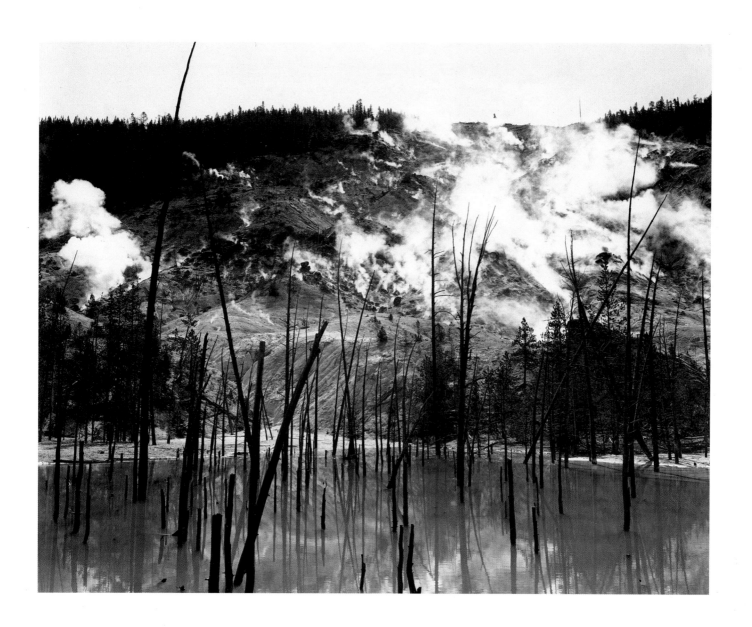

95. "Roaring Mountain, Yellowstone National Park"

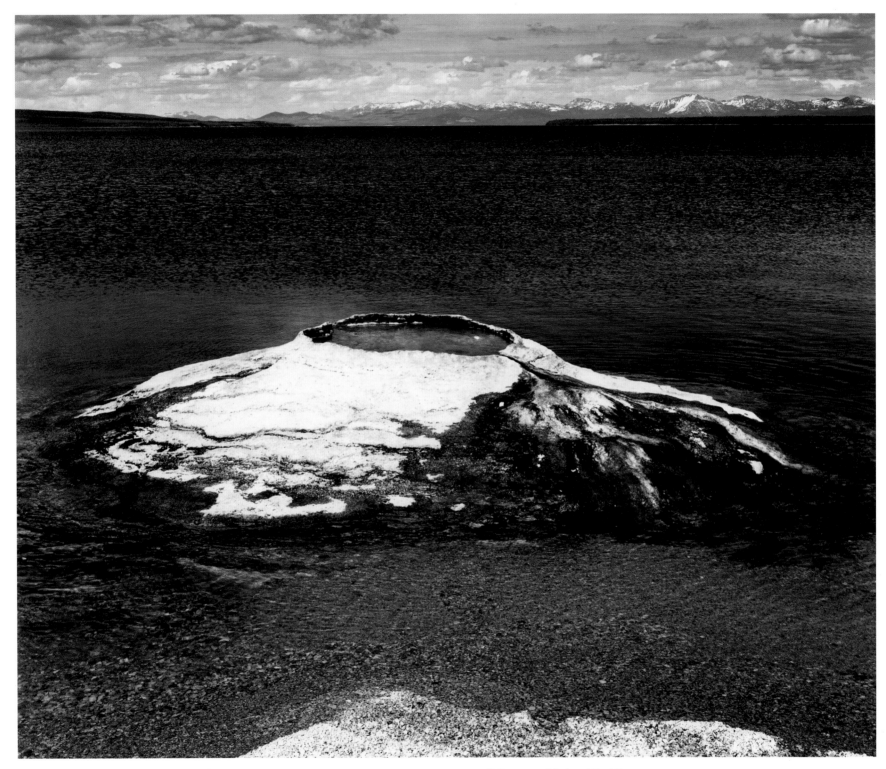

96. "The Fishing Cone—Yellowstone Lake, Yellowstone National Park"

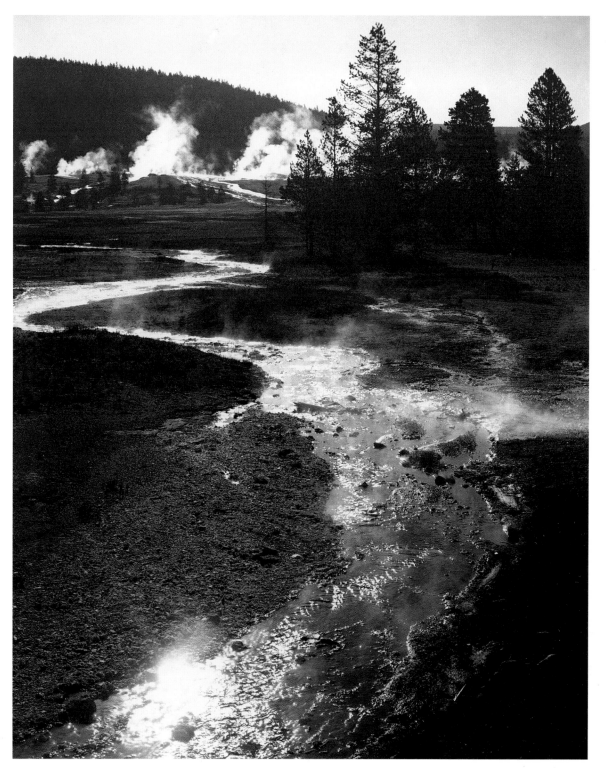

97. "Central Geyser Basin, Yellowstone National Park"

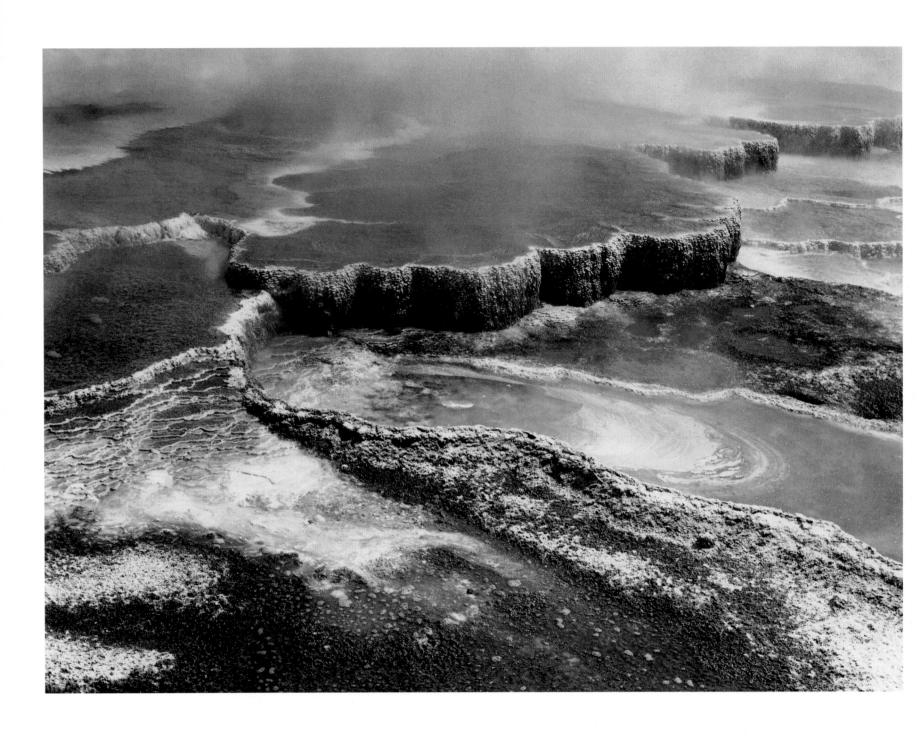

98. "Jupiter Terrace, Fountain Geyser Pool, Yellowstone National Park"

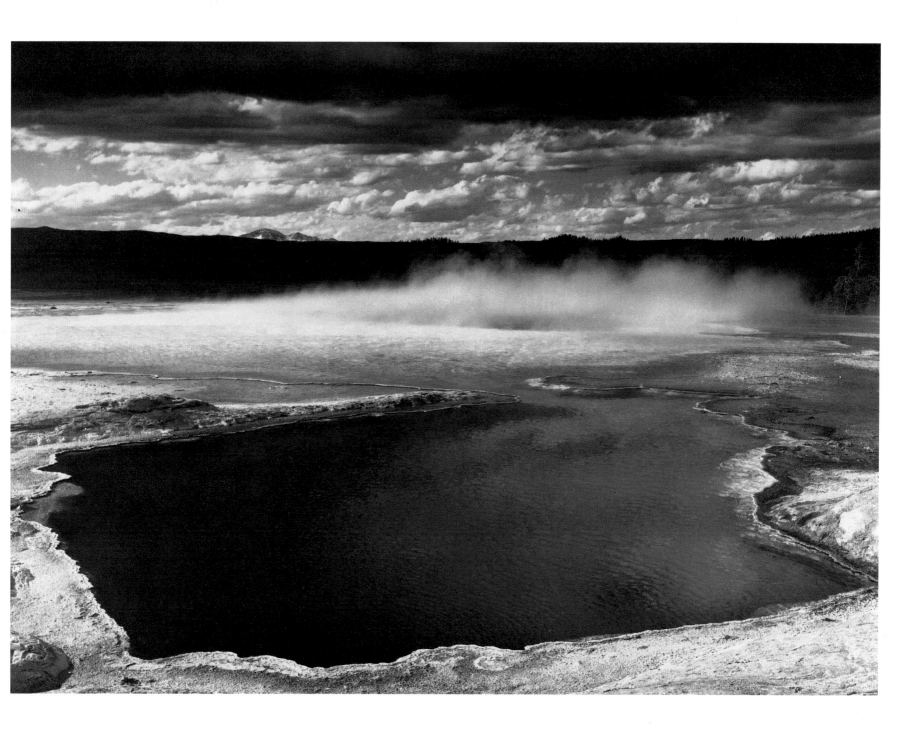

99. "Fountain Geyser Pool, Yellowstone National Park"

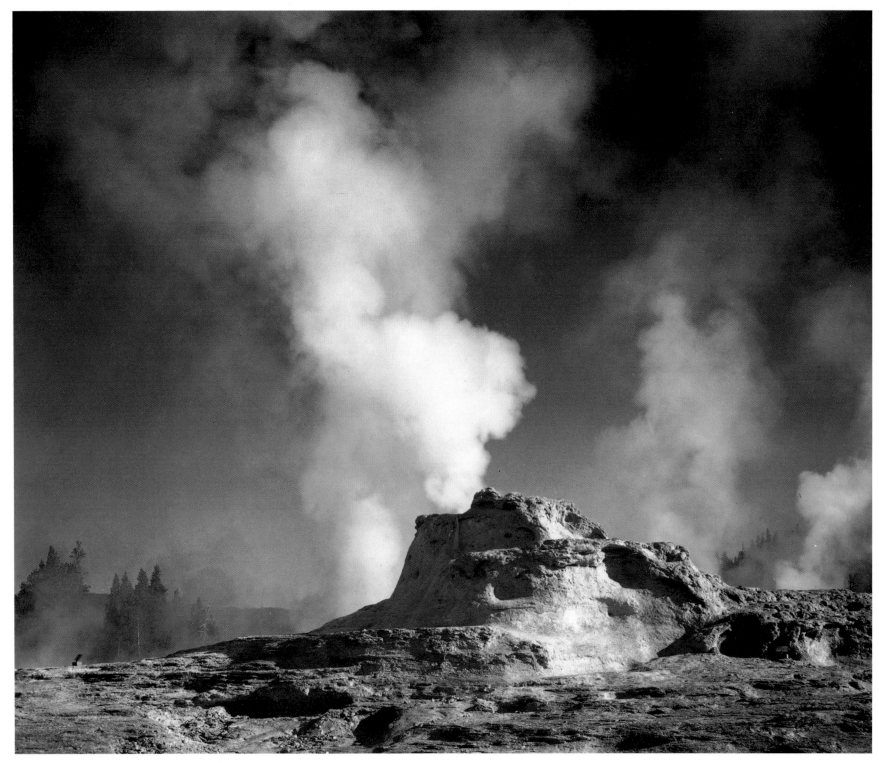

100. "Castle Geyser Cove, Yellowstone National Park"

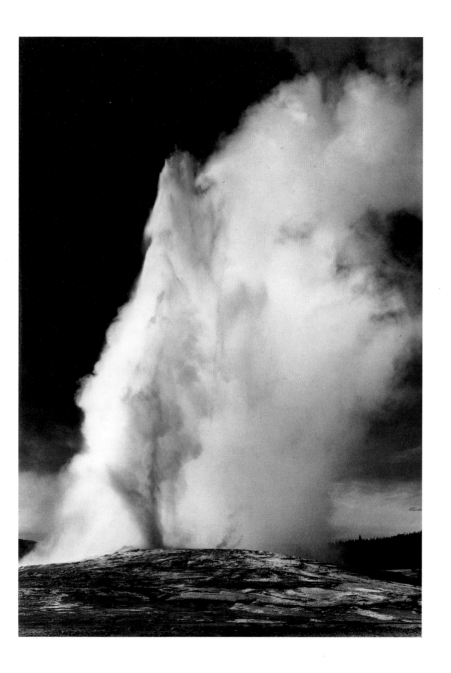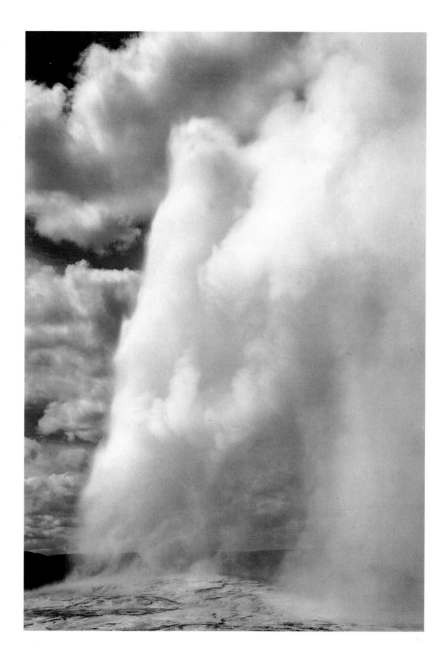

LEFT: 101. "Old Faithful Geyser, Yellowstone National Park"
RIGHT: 102. "Old Faithful, Yellowstone National Park"

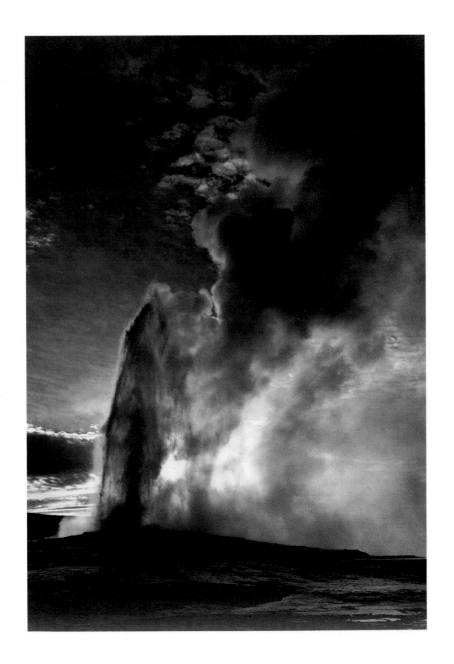

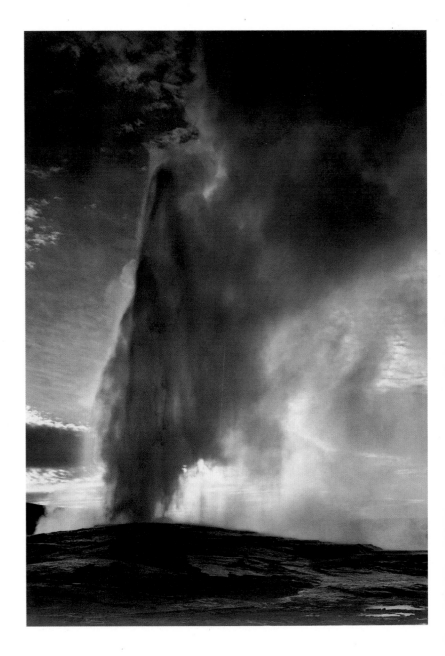

LEFT: 103. "Old Faithful, Yellowstone National Park"

RIGHT: 104. "Old Faithful, Yellowstone National Park"

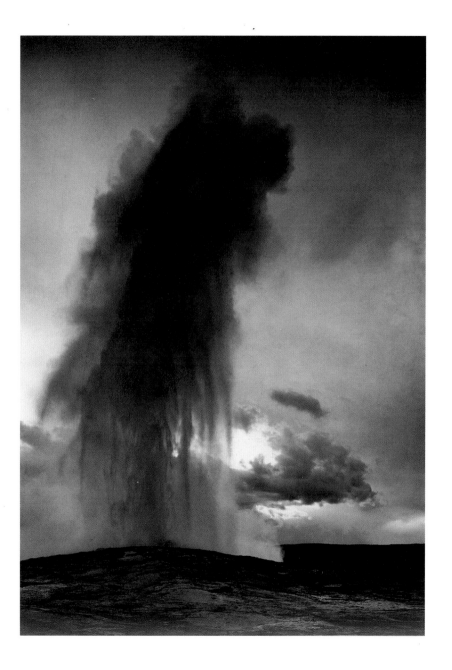

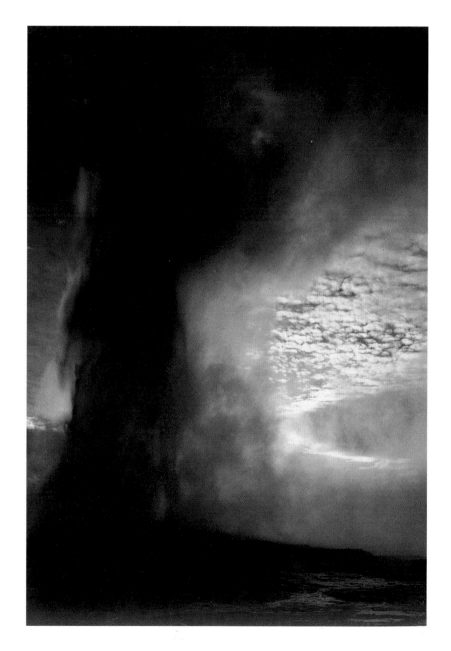

LEFT: 105. "Old Faithful, Yellowstone National Park"

RIGHT: 106. "Old Faithful, Yellowstone National Park"

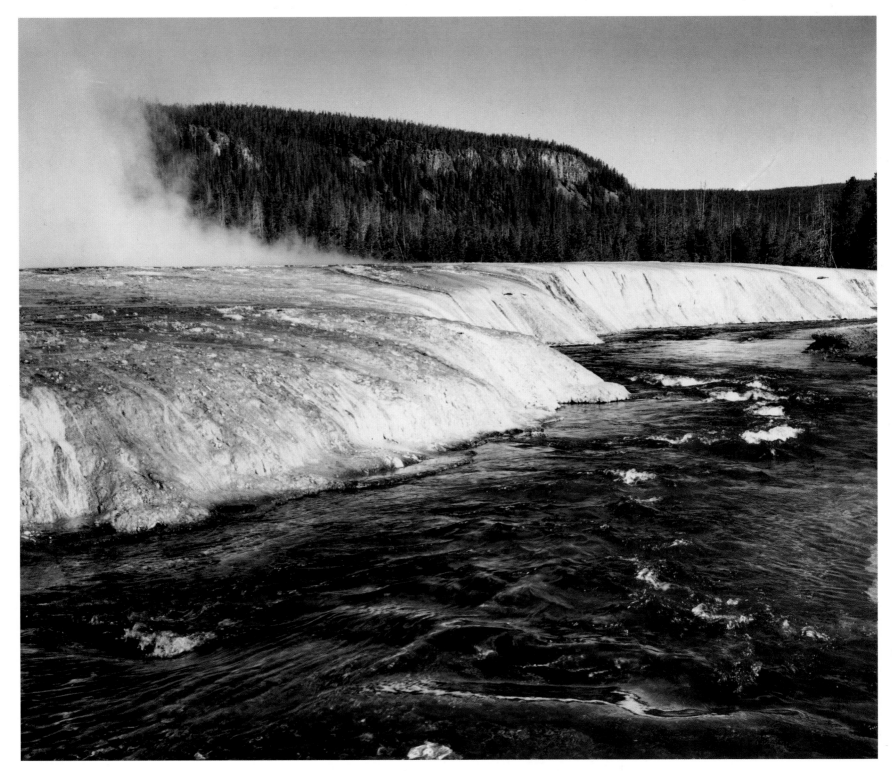

107. "Firehold River, Yellowstone National Park"

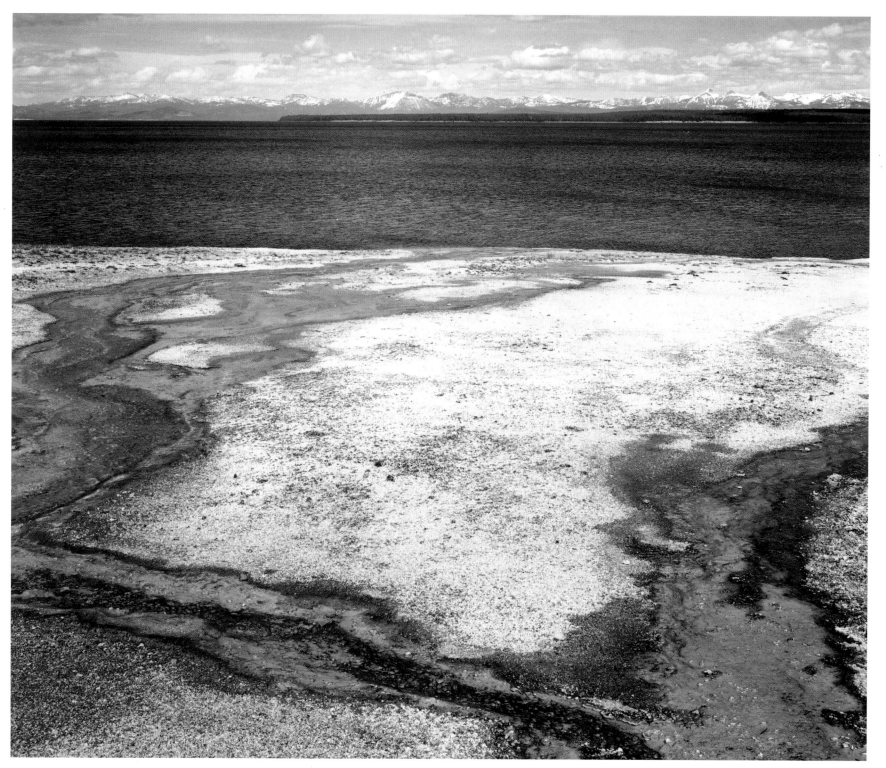

108. "Yellowstone Lake—Hot Springs Overflow, Yellowstone National Park"

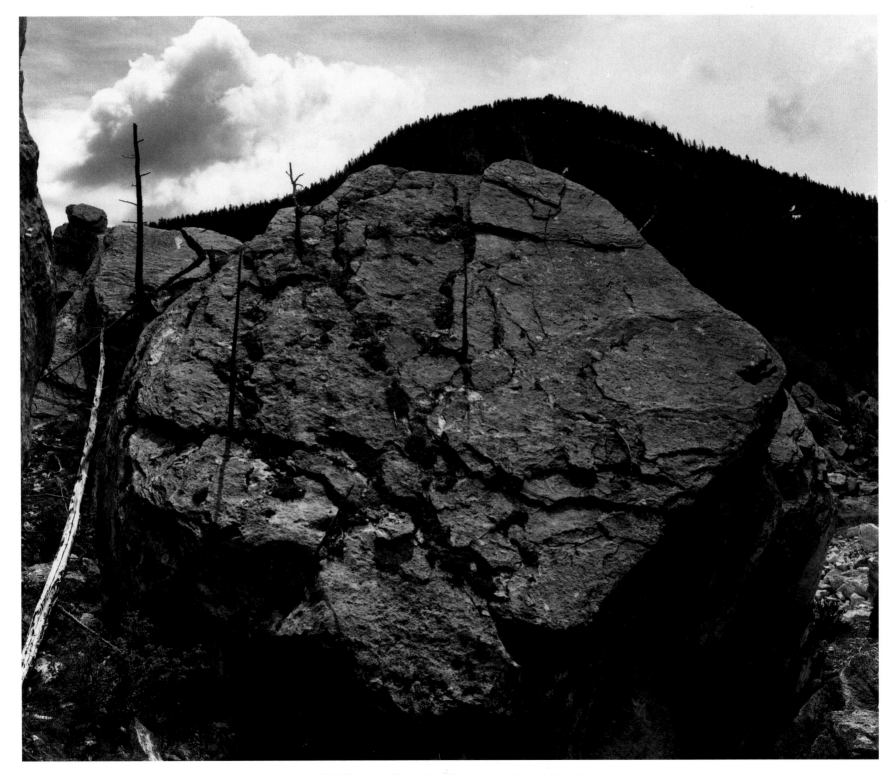

109. "Rocks at Silver Gate, Yellowstone National Park"

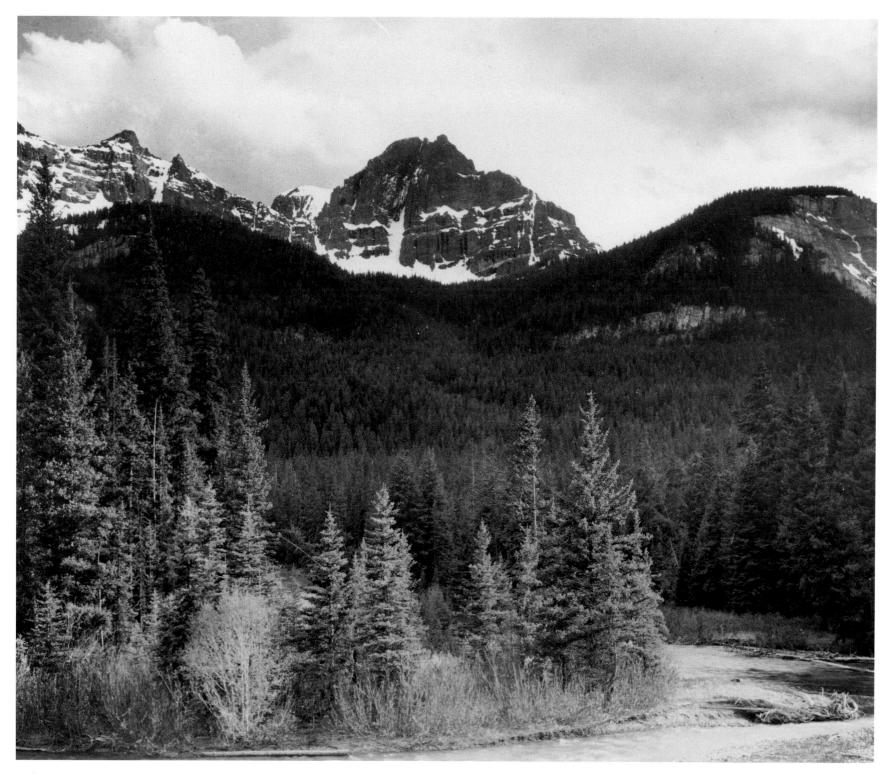

110. "Mountains—Northeast portion, Yellowstone National Park"

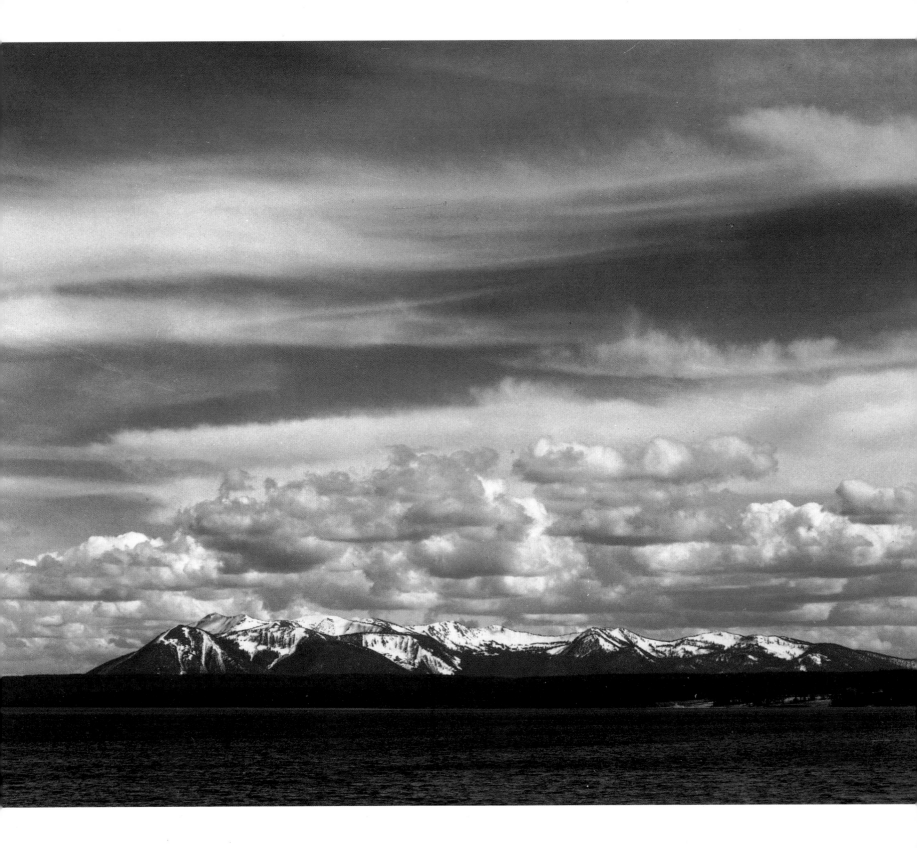

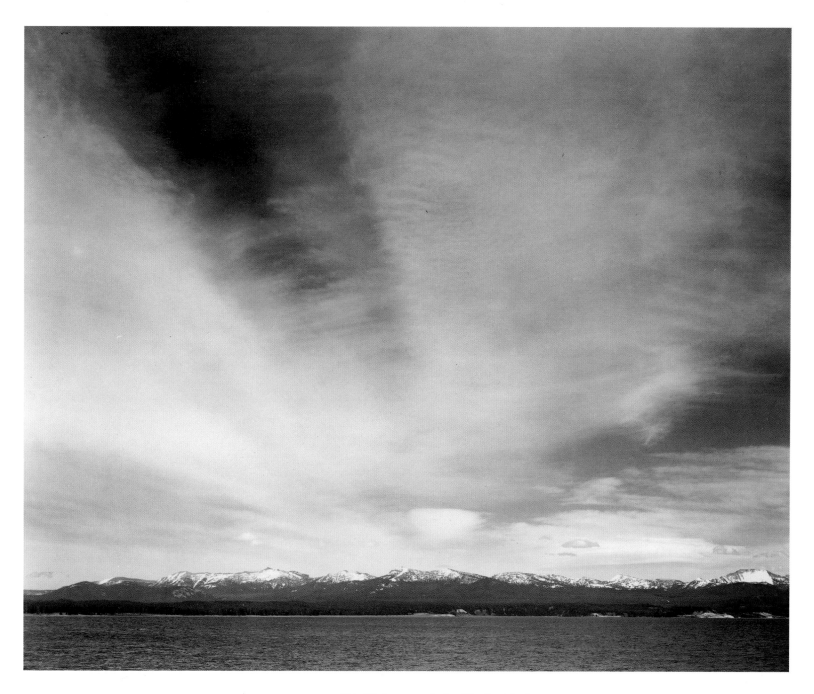

OPPOSITE: 111. "Yellowstone Lake, Mt. Sheridan"
ABOVE: 112. "Yellowstone Lake, Yellowstone National Park"

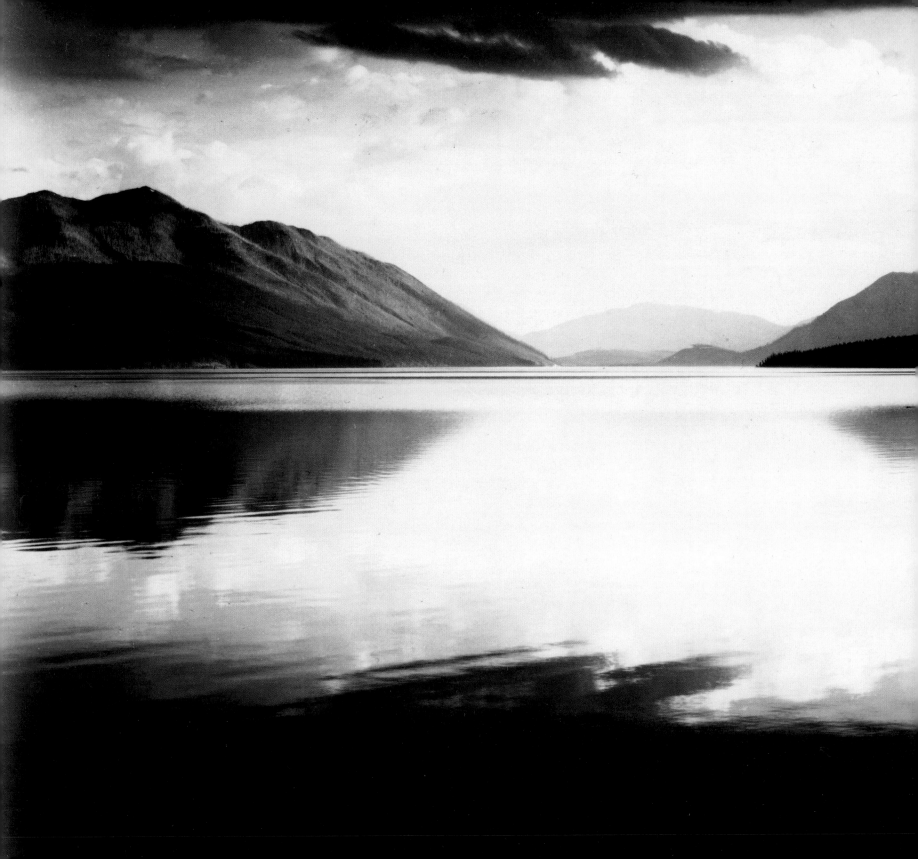

GLACIER
NATIONAL PARK

Montana

113. "Evening, McDonald Lake, Glacier National Park"

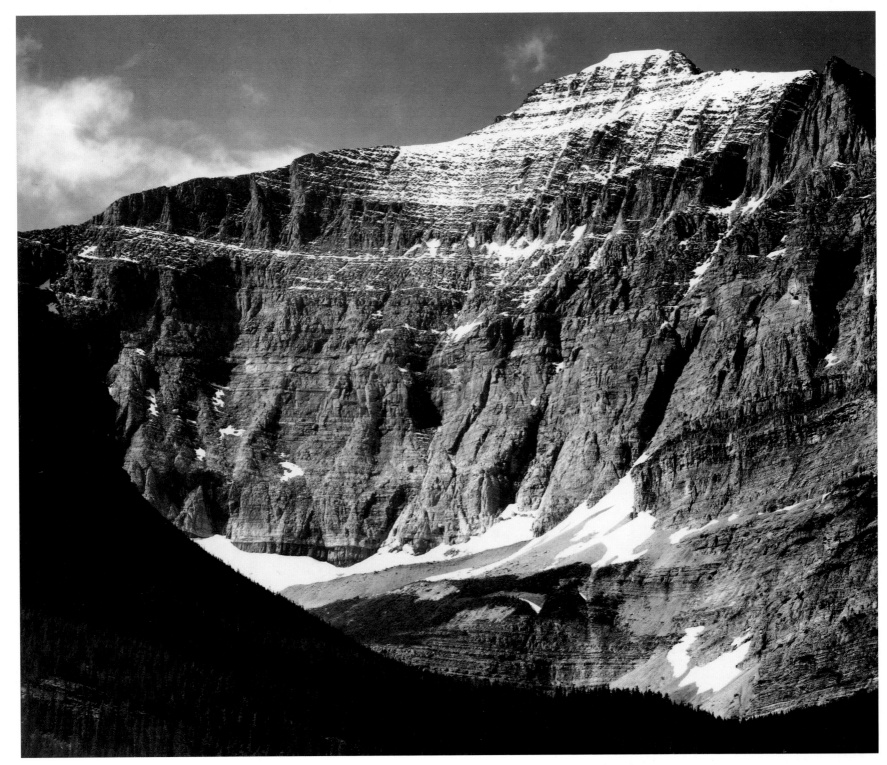

114. "From Going-to-the-Sun Chalet, Glacier National Park"

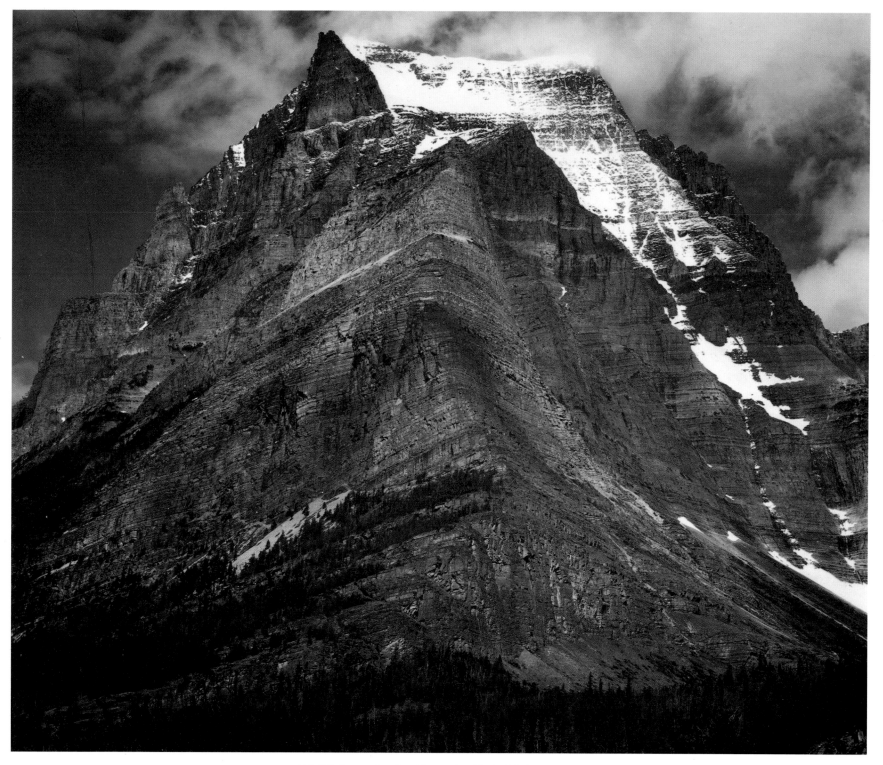

115. "Going-to-the-Sun Mountain, Glacier National Park"

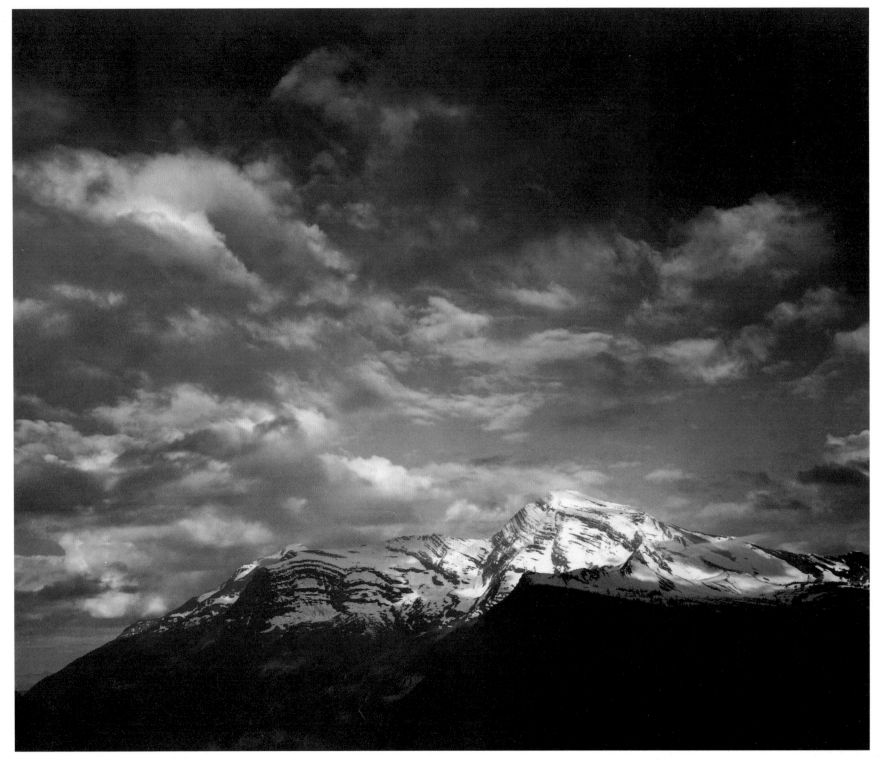

116. "Heaven's Peak"

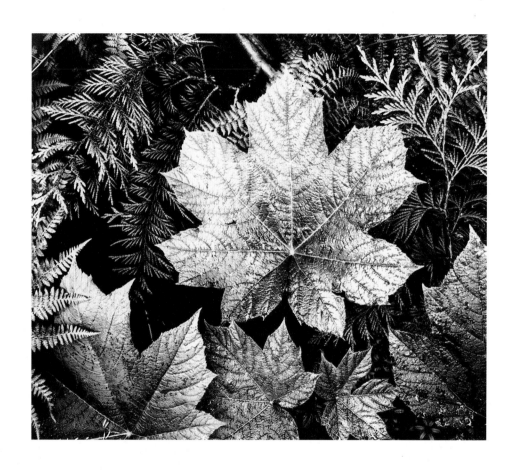

117. "In Glacier National Park"

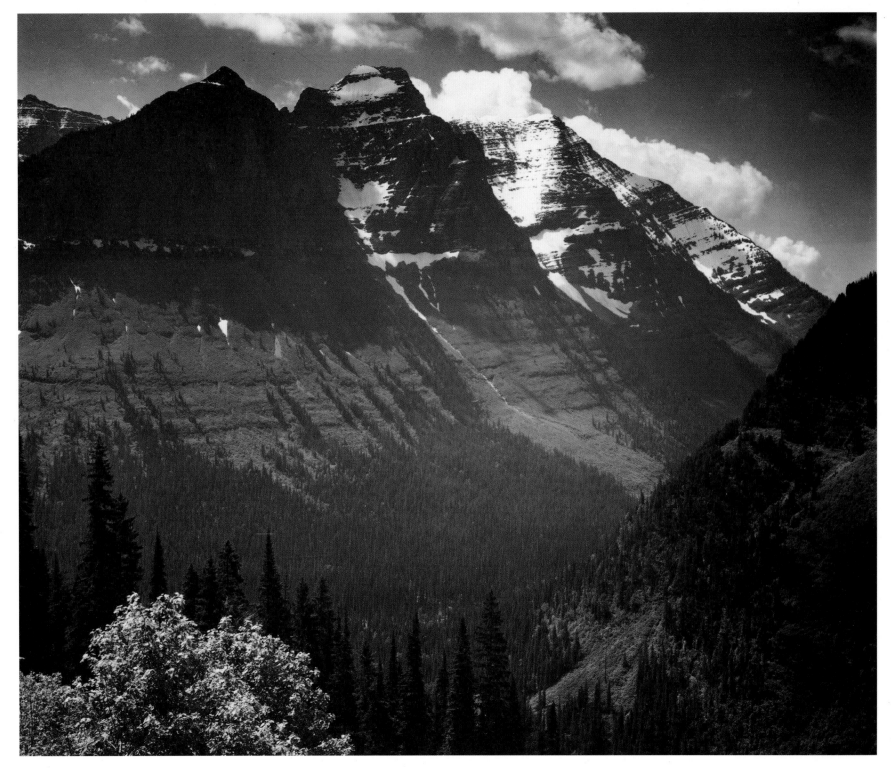

118. "In Glacier National Park"

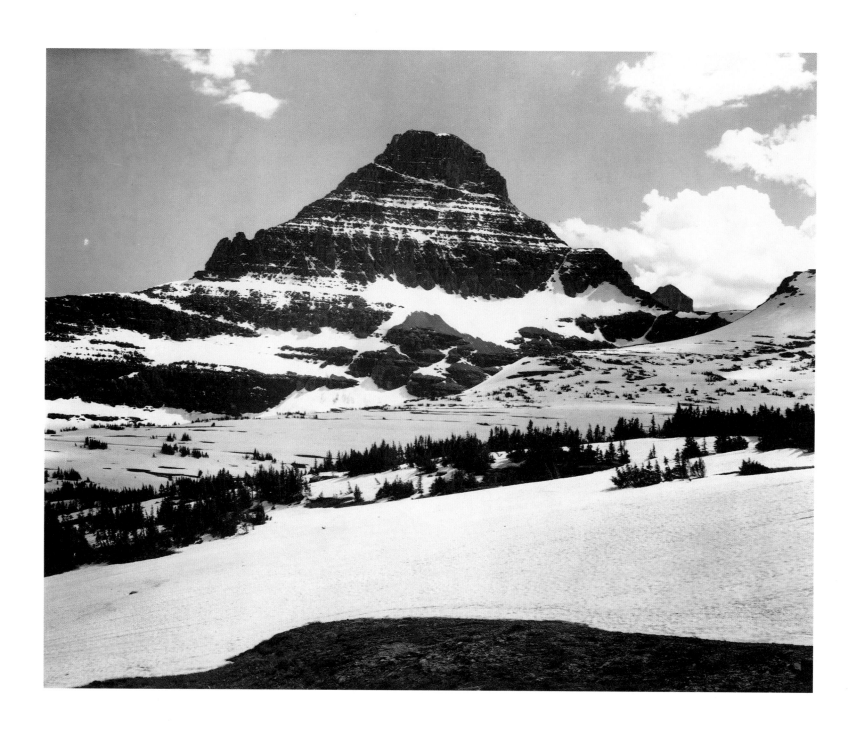

119. "From Logan Pass, Glacier National Park"

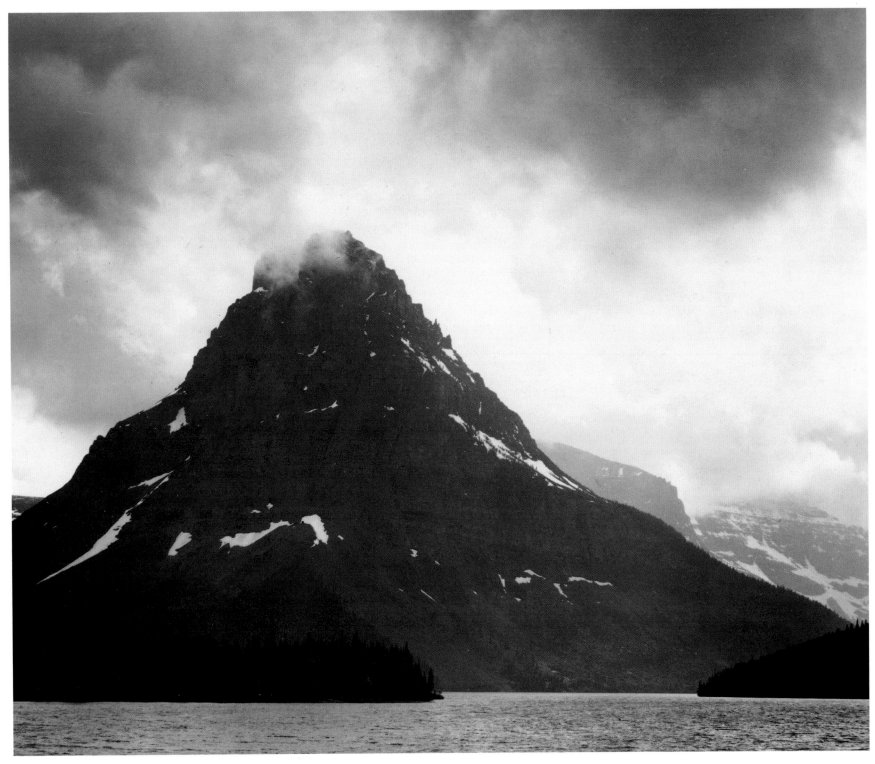

120. "Two Medicine Lake, Glacier National Park"

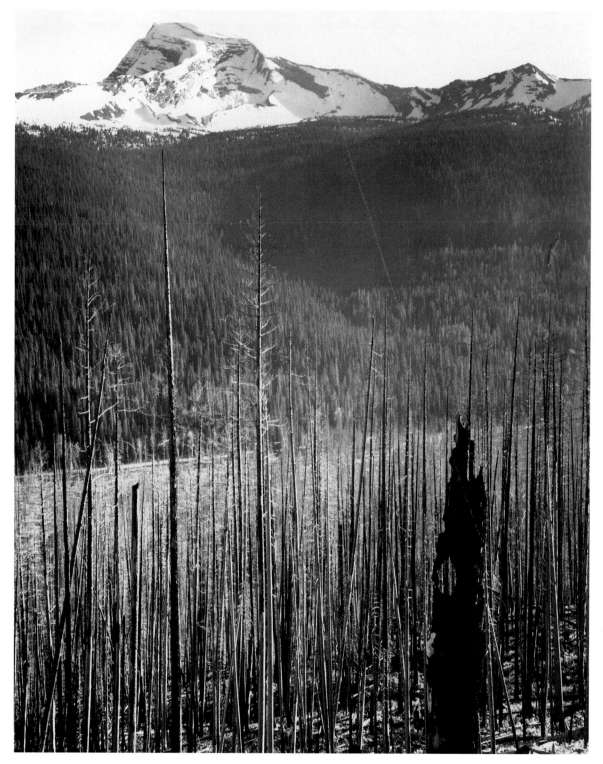

121. "Burned area, Glacier National Park"

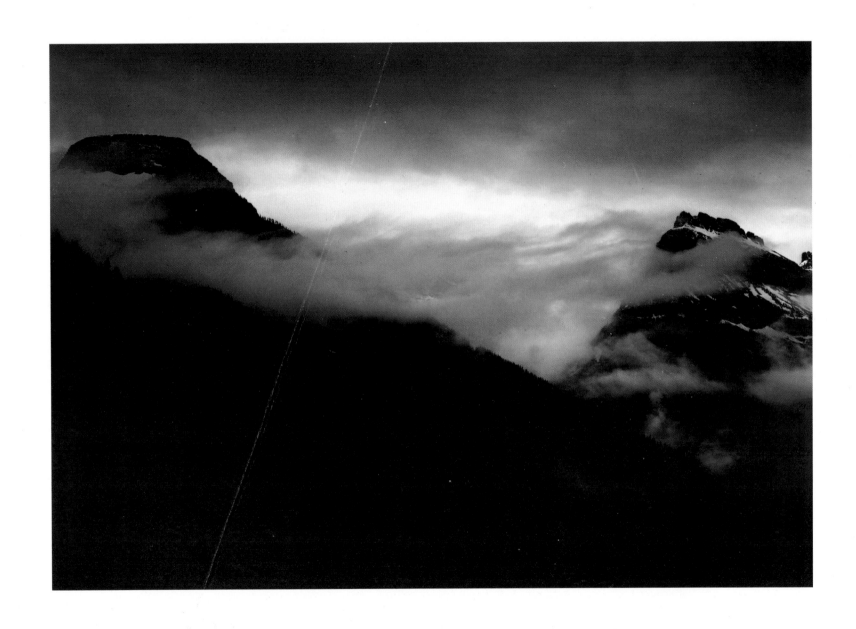

122. "In Glacier National Park"

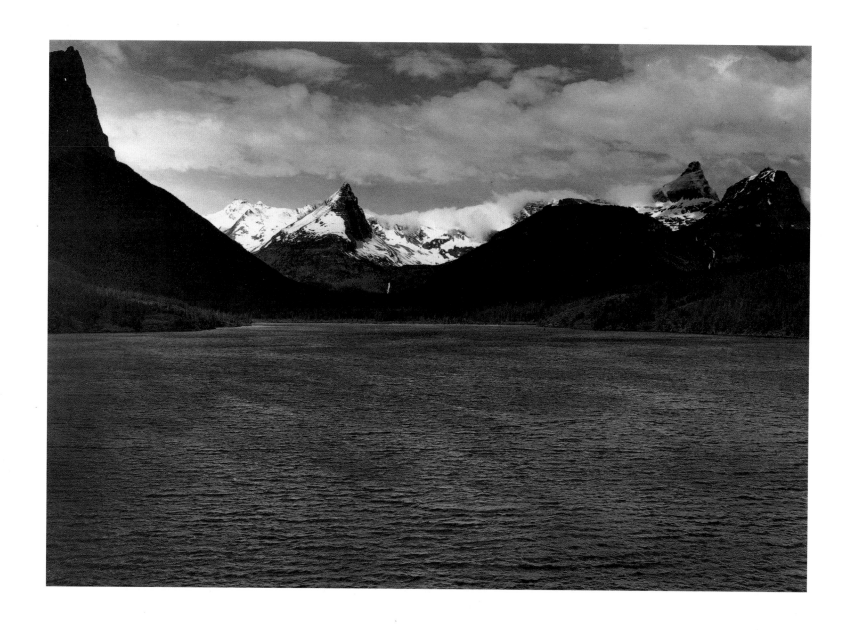

ABOVE: 123. "St. Mary's Lake, Glacier National Park"
OVERLEAF: 124. "McDonald Lake, Glacier National Park" (detail)

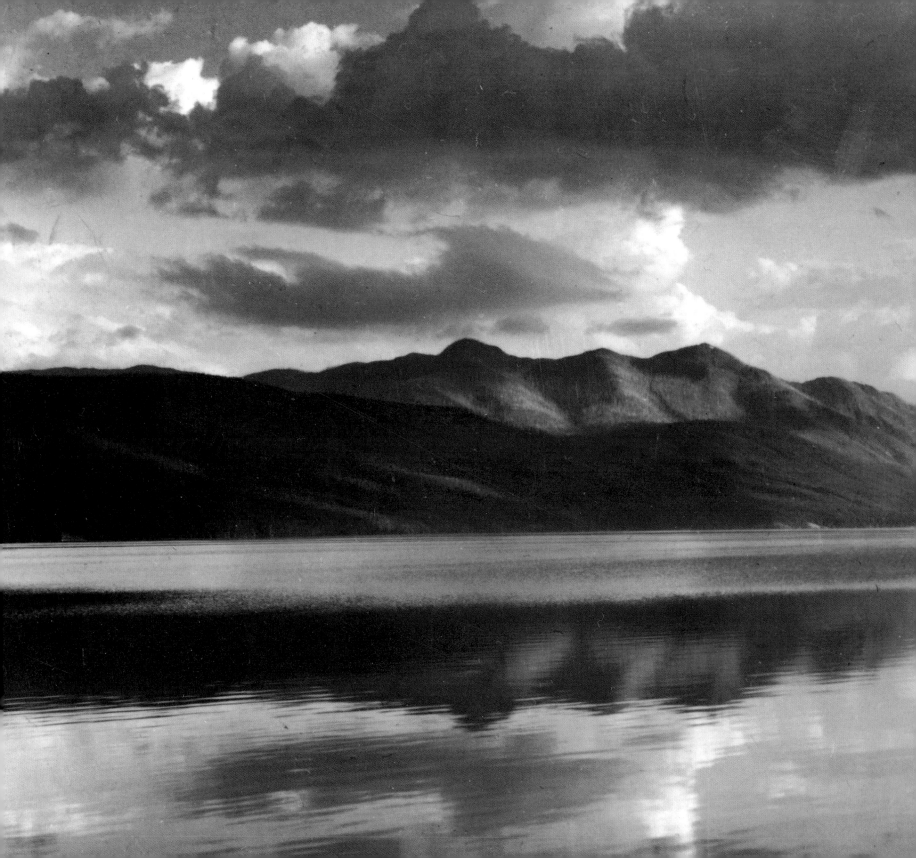

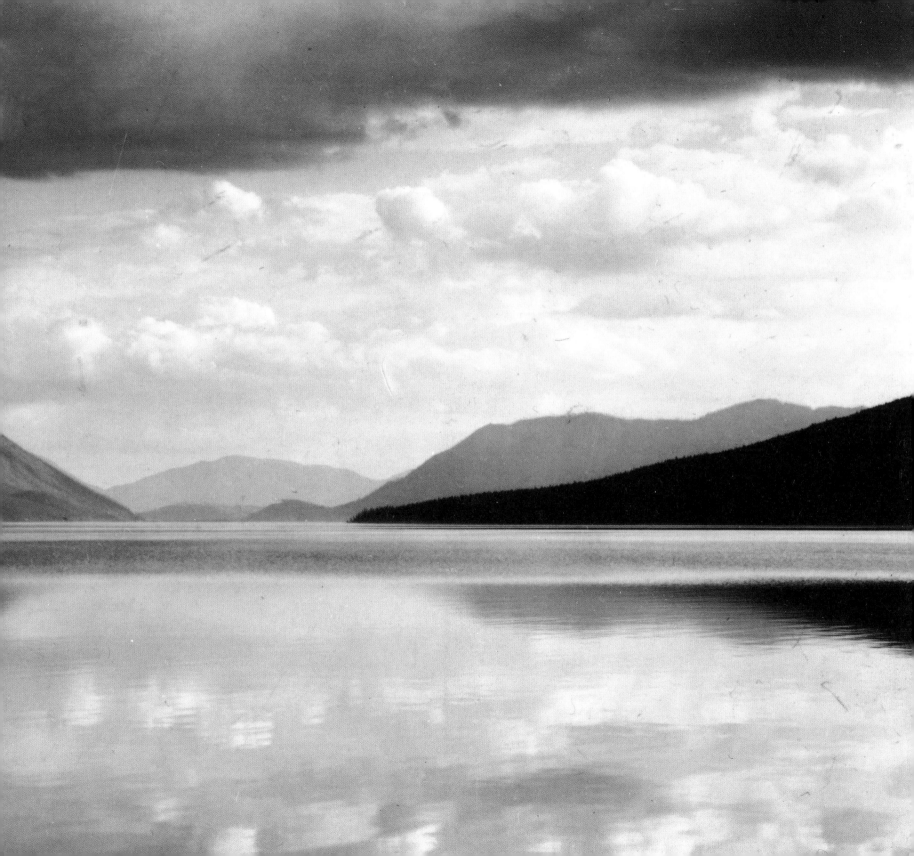

INDEX

BIBLIOGRAPHY

Adams, Ansel. "A Personal Credo." In *Photography: Essays and Images*, edited by Beaumont Newhall, pp. 255–62. New York: Museum of Modern Art; Boston: New York Graphic Society, 1980.
———. *Ansel Adams: An Autobiography*. With Mary Street Alinder. Boston: Little, Brown and Company, 1985.
———. *Ansel Adams: Letters and Images, 1916–1984*. Edited by Mary Street Alinder and Andrea Gray Stillman. Boston: Little, Brown and Company, 1988.
———. *Ansel Adams: Classic Images*. Boston: Little, Brown and Company, 1985.
———. *Examples: The Making of 40 Photographs*. Boston: Little, Brown and Company, 1983.

———. *My Camera in the National Parks*. Boston: Houghton Mifflin, 1950.
———. *The Mural Project*. Selected and with an introduction by Peter Wright and John Armor. Santa Barbara, California: Reverie Press, 1989.
———. *The Negative*. With Robert Baker. Boston: Little, Brown and Company, 1981.
———. *Our National Parks*. Edited by Andrea G. Stillman and William Turnage. Boston: Little, Brown and Company, 1992.
———. *The Portfolios of Ansel Adams*. Boston: Little, Brown and Company, 1977.
Newhall, Nancy. *Ansel Adams: The Eloquent Light*. Millerton, New York: Aperture Books, 1980.

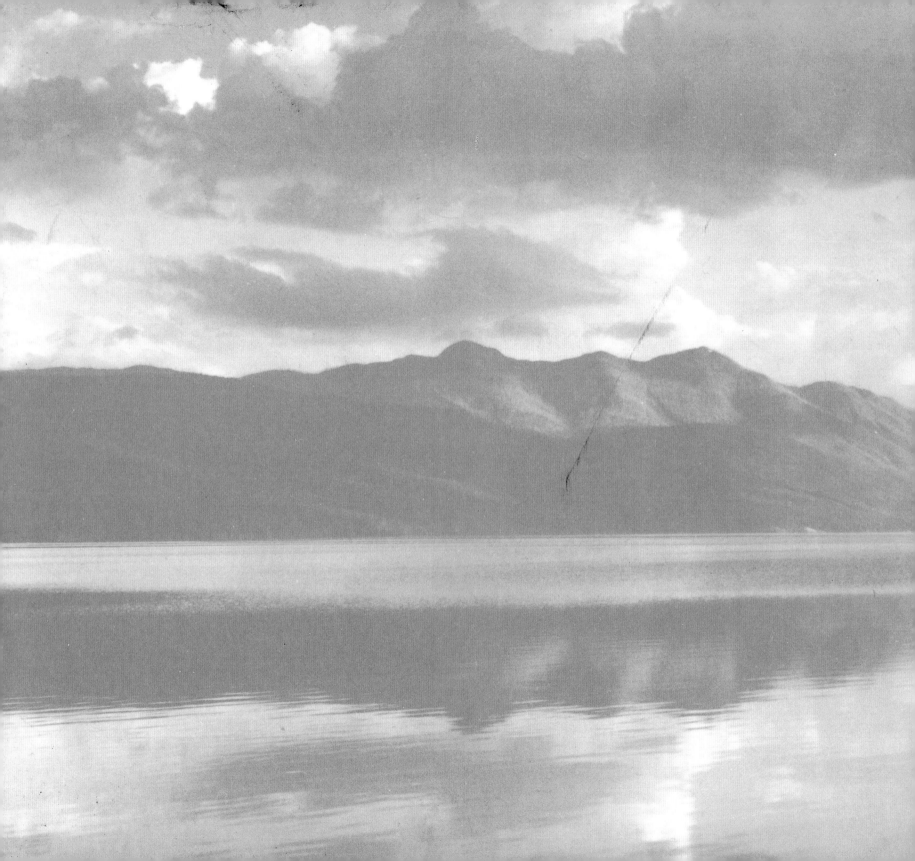